# PICTORIALISM

## IN CALIFORNIA

### PHOTOGRAPHS 1900–1940

With essays by
Michael G. Wilson and Dennis Reed

The J. Paul Getty Museum
The Henry E. Huntington Library
and Art Gallery

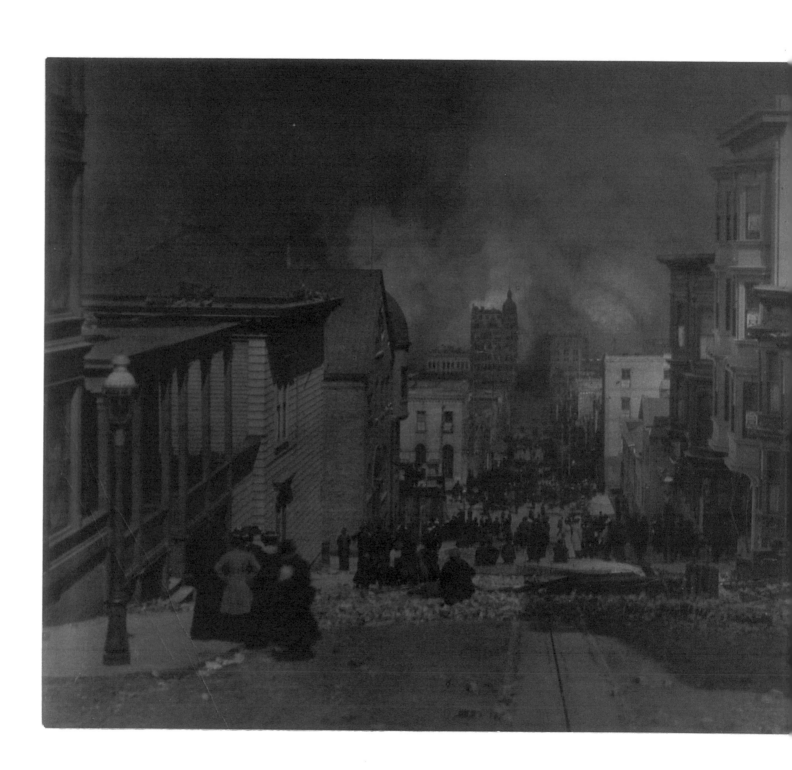

# CONTENTS

© 1994 The J. Paul Getty Museum and
The Henry E. Huntington Library and Art Gallery

Published by

The J. Paul Getty Museum
17985 Pacific Coast Highway
Malibu, California 90265-5799

and

The Henry E. Huntington Library and Art Gallery
1151 Oxford Road
San Marino, California 91108

Facing the title page:
(Cat. 54) Edward Weston, *Bathing Pool*, 1919 [detail]

On pages iv and v:
(Cat. 10) Arnold Genthe, *San Francisco, April 18, 1906*,
printed 1920s

Facing page 1:
(Cat. 12) Emily Pitchford, *Suspense*, 1908 [detail]

Facing page 67:
(Cat. 88) Hiromu Kira, *Curves*, c. 1930 [detail]

Library of Congress Cataloging-in-Publication Data

Wilson, Michael (Michael Gregg)
    Pictorialism in California : photographs 1900–1940 / by Michael
Wilson and Dennis Reed.
        p.   cm.
    Catalog of exhibitions held at the J. Paul Getty Museum and the
Huntington Library, Sept. 13–Nov. 27, 1994.
    Includes bibliographical references (p.      ).
    ISBN 0-89236-312-6   ISBN 0-89236-313-4 (pbk.)
    1. Photography, Artistic—Exhibitions.   2. Photography—
California—History—Exhibitions.   3. Photographers—California—
Exhibitions.   I. Reed, Dennis (Dennis James).   II. J. Paul Getty
Museum.   III. Henry E. Huntington Library and Art Gallery.
IV. Title.
TR645.S3642J228   1994
779'.09794'07479793—dc20                              94-14039
                                                      CIP

At The J. Paul Getty Museum

Christopher Hudson
    Publisher

Mark Greenberg
    Managing Editor

Charles Passela
    Head of Photographic Services

Rebecca Branham
    Photographic Technician

At The J. Paul Getty Trust Publication Services

Martha Drury
    Production Coordinator

Kurt Hauser
    Designer

At The Henry E. Huntington Library and Art Gallery

Peggy Park Bernal
    Director of Publications

# FOREWORD

Occasionally a subject materializes that is best handled by the collaboration of two institutions. California Pictorialism is one of these: it maximizes the potential of the J. Paul Getty Museum and the Henry E. Huntington Library and Art Gallery, each of which has complementary holdings in its collection of photographs. The Getty and the Huntington have joined forces to publish in one book the contents of two separate exhibitions devoted to photographic Pictorialism in California. The Getty's strength lies in the East Coast roots of Pictorialism in the circle of Alfred Stieglitz and in a limited holding of Stieglitz's West Coast followers in the Bay Area. The Huntington's lies in the later manifestations of Pictorialism in Southern California. These collections, complemented by works from private and institutional collections, constitute an important but little recognized chapter in the history of photography. We hope that this catalogue, enriched by the essays of Michael G. Wilson and Dennis Reed, will spur further interest and research in this regional manifestation of an international photographic movement.

*John Walsh*
Director
The J. Paul Getty Museum

*Edward Nygren*
Director of the Art Collections
The Henry E. Huntington Library
and Art Gallery

# PREFACE

California is physically one of the most remarkable places in the United States. Its main geographical features are varied and bold, making it a magnet for photographers. Because the state is almost eight hundred miles long, map makers often divide it in half with a transverse line between Santa Cruz—a city on the Pacific Ocean located approximately one hundred miles south of San Francisco—and a remote spot in Death Valley at the border with Nevada. California has thus been historically bisected into North and South, with San Francisco as the hub of the upper half and Los Angeles as the pivot of the south. The two cities are separated by almost four hundred miles of ranch and agricultural land, and they developed independent social, cultural, and artistic traditions that, by 1900, came to be reflected in all the arts, including photography.

The distinctness of each region is reflected in the photographic works of art produced in Northern and Southern California under the broad compass of Pictorialism, a style of photography that had its roots in the self-consciously painterly art of nineteenth-century European photographers such as Henry Peach Robinson and Peter Henry Emerson. Two different approaches to Pictorialism are illustrated in two separate exhibitions, one installed at the J. Paul Getty Museum and the other at the Henry E. Huntington Library and Art Gallery. The contents of both exhibitions are here joined within the covers of a single publication in two studies, one by Michael G. Wilson and the other by Dennis Reed. The two essays trace the various historical and cultural influences on the course of Pictorialist photography in California in the first half of the twentieth century, and the authors bring their own special qualifications to the project from their experience as collectors of different aspects of California Pictorialist photography.

In 1978 Michael G. Wilson acquired Anne Brigman's *The Heart of the Storm*, the first American photograph and the first work of California Pictorialism in his collection. Until that time he had devoted himself almost exclusively to works from the first fifty years of photography and his collection had consisted of a few dozen, mostly European, photographs. Inspired by the strong impression Brigman's picture made on him, Wilson began to search for work by other Bay Area photographers of her circle. This led him to acquire works by Laura Adams Armer and Emily Pitchford, among others. Perhaps no other art form was so molded by women practitioners, and Wilson interprets Northern California Pictorialism through the lens of its female participants.

Dennis Reed came to an appreciation of California Pictorialism through a similar experience. In 1980 he met Hiromu Kira, one of the most respected of a group of Southern California Pictorialists, who, like many other influential California photographers, was of Japanese ancestry. Reed's interest was sparked, and he decided to organize the first historical exhibition devoted to those Japanese-American photographers who were active before World War II. Starting from the perspective of its Japanese practitioners, Reed studied the Southern California Pictorialist movement in general and began to collect the work of its chief participants as well as to seek out living artists from this period and their families.

•　　　　•　　　　•

We wish to thank the following persons who contributed significantly to the realization of this project. At the J. Paul Getty Museum: Katherine C. Ware, curatorial assistant, who administered many details of the joint project and helped to shape the contents of the two exhibitions; Jeanie Won and Elizabeth Daniels for their research assistance; Marc Harnly, associate conservator and Ernie Mack, senior conservation assistant, who prepared the photographs for exhibition; Christopher Hudson, head of museum publications, who supported the idea of a joint publication, and his assistant, Leslie Rollins, who coordinated the logistics of the publication; Charles Passela, head of photographic services, who skillfully made the reproduction photographs from originals that resist faithful duplication; Joan Gallant Dooley and Cory Gooch, who coordinated the logistics of the loans; and Kurt Hauser, who designed the publication.

At the Huntington: Jacqueline Dugas, assistant to the director of the art collections, and Deidre Cantrell, administrative assistant, who carried forward many of the preparations for the exhibition on Southern California Pictorialism; Eric Lutz, preparator, who prepared the photographs for exhibition and designed their installation; Peggy Park Bernal, publications director, who oversaw the editing of this publication; and Guilland Sutherland, who served as copy editor. The Huntington wishes to express additional appreciation to the National Endowment for the Arts, a federal agency, and Dr. Richard K. Nystrom for support of this project.

The authors wish to thank Paul Hertzmann, Tom Jacobson, Peter Palmquist, Stephen White, and Carla Williams for their research assistance relating to some of the more obscure California Pictorialists; Will Connell, Jr., Michael Dawson, and Janet Tearnen for their assistance on Will Connell; Susan Ehrens for her assistance on Anne Brigman, Alma Lavenson, and Imogen Cunningham; Richard W. Gadd for research materials on Leopold Hugo; Robert MacKimmie for information about Laura Adams Armer; Kirby Kean and Herman V. Wall for relating their personal knowledge; and the lenders (see p. 158).

Both of us would also like to thank the institutions and private collectors who have so generously lent their works to this exhibition. Finally, we wish to thank Michael G. Wilson and Dennis Reed, whose knowledge, discerning eyes, and enthusiasm have brought a fresh understanding to a subject they care deeply about.

*Weston Naef*
Curator of Photographs
The J. Paul Getty Museum

*Amy Meyers*
Curator of American Art
The Henry E. Huntington Library
and Art Gallery

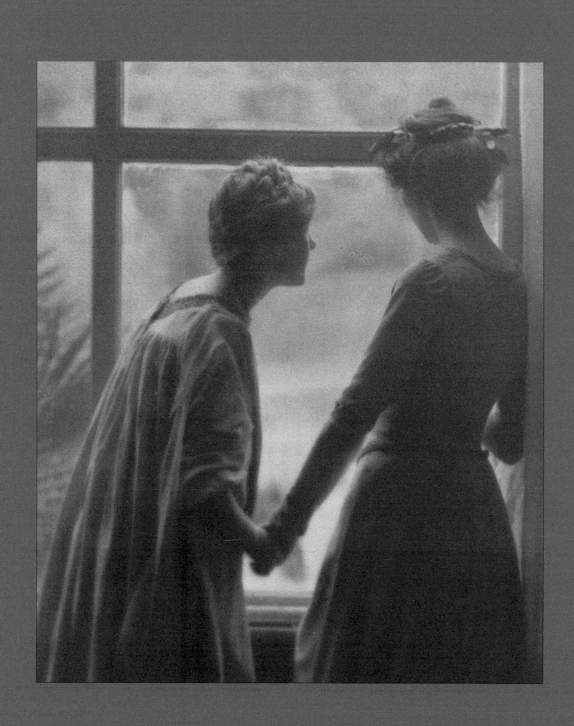

# NORTHERN CALIFORNIA:

## THE HEART OF THE STORM

Michael G. Wilson

For the first forty years after the invention of photography, its practice was confined to serious amateurs and dedicated professionals, but as photography advanced and became simpler, commercial and dilettante photographers entered the field. By the 1880s Eastman Kodak could advertise, "You press the button, we do the rest." Thousands of commercial photographers and a hundred times as many amateurs were producing millions of photographs annually. Due to competitive cost cutting, professional establishments had become assembly-line operations, and their work had become stilted and artificial. The decline in quality of professional work and the deluge of snapshots (a term borrowed from hunting, meaning to get off a quick shot without taking time to aim) resulted in a world awash with technically good but aesthetically indifferent photographs. In the words of California photographer Laura Adams, the sheer ease with which "anyone of ordinary intelligence could manufacture a photograph"[1] created a situation in which critics were able to challenge the right of any photographer to call him- or herself an artist. Serious photographers were compelled to seek a framework where their achievements would be recognized and their interests promoted; the photographic style of Pictorialism, which evolved in the final decades of the nineteenth century, offered just such a framework.[2]

•        •        •

Henry Peach Robinson, the renowned art photographer, attempted to define the laws of artistic photography in his book *Pictorial Effect in Photography* published in 1869. Robinson's "aim was to set forth the laws which govern . . . the arrangement of a picture, so that it shall have the greatest amount of pictorial effect." The term "pictorial photography" was used by Robinson to distinguish it from technical, documentary, and scientific photography. The closest he came to a definition appears in chapter 3 of his book: "By the preservation of a harmonious balance of lines and light and shade, several objects are attained. The first and simplest result is the production of pictorial effect."[3] Seeking a "pictorial effect" soon became known as pictorial photography, or Pictorialism, and the term quickly became synonymous with art photography.

Robinson's ideas present an interesting dichotomy in light of later developments. He insisted that the final picture must be true to nature: "The photographer must not let his invention tempt him to represent, by any trick, any scene that does not occur in nature." In an apparent contradiction, however, Robinson goes on to add, "But any 'dodge, trick, or conjuration'

of any kind is open to the photographer's use, *so that it belongs to his art, and is not false to nature.*"[4] The contradictions are present in one of Robinson's best-known images, *Fading Away* [Fig. 1], where a grieving family surrounds a dying young woman. The picture was printed with a combination of five separate negatives, taken at widely different times and places. Thus Robinson advocates such technical manipulation to achieve a dramatically sensational effect, the only reservation being that the resulting image "not [be] false to nature." Though the scene was a complete fabrication, Robinson's picture was true enough to nature to incite public outcry that he would photograph an intimate deathbed gathering.

An even more elaborate example of combination printing in the nineteenth century is *The Two Ways of Life* [Fig. 2] by the Swedish-born British photographer Oscar Gustave Rejlander. The picture illustrates an allegorical tale of two young men at the threshold of life; one chooses "Religion, Charity, and Industry," the other chooses "the pleasures of the world . . . Wine, Licentiousness and other vices." The first reaches old age surrounded by family and wealth, the second comes to a sticky end—"Suicide, Insanity, and Death." In order to create the picture, Rejlander hired a group of itinerant players to act as models. The final image, measuring thirty-one by sixteen inches, is composed of thirty separate negatives and is a picture that has been "built" like a painting rather than "taken" as a snapshot.[5]

In his 1889 book *Naturalistic Photography*, physician-turned-photographer Peter Henry Emerson challenged Robinson's artistic tenets by attacking combination printing as contrary to the nature of photography. He subscribed to the widely held nineteenth-century view that perfection and beauty are to be found by the artist in nature. What better medium than photography to explore nature, Emerson proposed. But photography must be allowed to show nature truthfully, not debased by manipulation. Emerson proclaimed photography an independent art in its own right. It was unnecessary, indeed improper, for it to imitate other art forms. He believed individualism and emotion could best be expressed through straight photography without the manipulation of such processes as combination printing. If Emerson were to have stopped at that point, he would have been in full agreement with traditional photographic purists. But he went a step further.

Believing it was the artist's duty to reflect nature as it was seen, Emerson consulted the *Handbook of Physiological Optics,* the contemporary work on optics and the eye published in

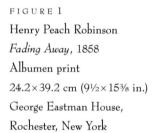

FIGURE 1
Henry Peach Robinson
*Fading Away*, 1858
Albumen print
24.2 × 39.2 cm (9½ × 15⅜ in.)
George Eastman House,
Rochester, New York

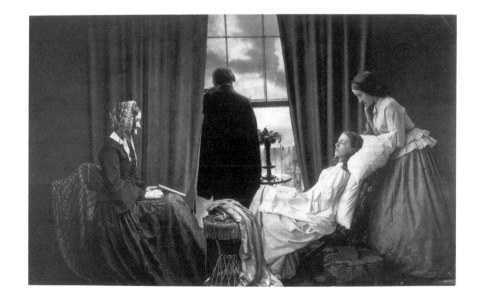

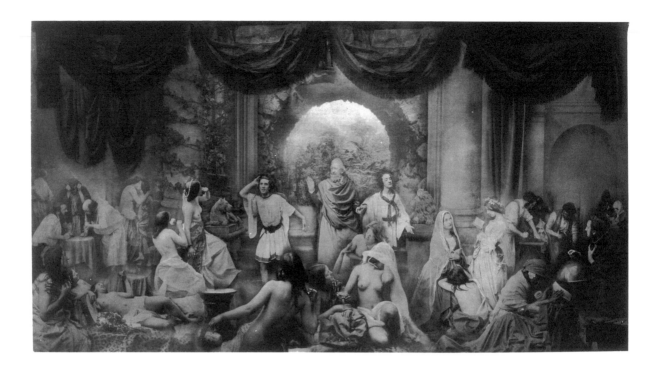

FIGURE 2
Oscar Gustave Rejlander
*The Two Ways of Life,* 1857
Albumen print
The Royal Photographic
Society, Bath

1867 by the German physicist Hermann von Helmholtz. In Helmholtz's view, the human eye saw at most only a small selective portion of the visual field in focus at any one time. Emerson advocated setting the camera lens slightly out of focus, the better to interpret nature according to this theory. But not too much: "'fuzziness' must not be carried to the length of *destroying the structure* of any object," he warned, "otherwise it becomes noticeable and is then just as harmful as excessive sharpness."[6]

Robinson was unimpressed by this approach, writing, "The fact that the eye could not see everything all at once is of course not a new discovery, but that the eye should not be allowed to ramble while looking at nature undoubtedly was."[7] *Poling the Marsh Hay* [Fig. 3] is a typical example of Emerson's style. The slightly soft focus balances the atmospheric effects of the marsh mists. The inhabitants are real, hardworking people, not sentimentalized fictions as was so often the case in genre photographs of the nineteenth century.

The most significant artistic influence on photographic Pictorialism came from a movement known as Tonalism, a major painting style popular in America during the 1880s and 1890s. The Tonalists were inspired by James McNeil Whistler and, like Emerson, they saw the interpretation of the experience of nature as the artist's duty. The artist, in addition to representing nature, had to convey his emotional response to it. This was achieved by the use of "tone." In the words of a modern writer on Tonalism, "This was a new form of idealism in art. Not an idealism of perfecting the forms of nature as in older, classical theory, but an idealism centered on the experience of nature."[8] California Pictorialists had direct access to the work of two of America's leading Tonalists, both of whom were resident in the Bay Area: Charles Rollo Peters, famous for his blue-green nocturnes, and Xavier Martinez, who had studied in Paris for six years before returning to Berkeley in 1901.

•       •       •

FIGURE 3

Peter Henry Emerson
*Poling the Marsh Hay*,
Plate XVII from *Life and
Landscape on the Norfolk Broads*,
by P. H. Emerson and
T. F. Goodall, 1886
Photogravure
Plate size: 23.6 × 29.0 cm
(9¹⁵⁄₁₆ × 11⁷⁄₁₆ in.)
The J. Paul Getty Museum

The era of Pictorialism in America arguably began in 1892 with the return to America of Alfred Stieglitz after he had studied photography in Germany for several years. He was familiar with the work of the leading European art photographers and was conversant with the aesthetic theories of Robinson and Emerson. Stieglitz preferred the naturalistic approach of Emerson in his own work, but as editor, publisher, critic, and collector he showed no bias for either camp.

Upon his arrival in the United States, Stieglitz took an editorial position with the *American Amateur Photographer*, a leading national periodical directed toward the serious nonprofessional photographer. The word "amateur" did not suggest, as it does today, an inexperienced novice. On the contrary, the word connoted a striving for artistic excellence and a freedom from outside influence that was thought to be lacking in professionals. A note in the first issue of *Amateur Photographer*, a British journal, commenting on the 1884 Royal Photographic Society Exhibition, states that "photography is an art—perhaps the only one in which the amateur soon equals, and frequently excels, the professional in proficiency."[9]

The 1893 Hamburg International Photographic Exhibition showed only amateur work. Alfred Lichtwark, the director of the Hamburg Kunsthalle, believed "that the only good portraiture in any medium was being done by amateur photographers, who had the economic freedom and time to experiment."[10] The idea that only the amateur—one who literally "does it for love," not money—had the requisite purity of motive and the leisure to experiment was a fundamental belief of Pictorialists, a belief Stieglitz never entirely abandoned.

As editor of *American Amateur Photographer*, Stieglitz was able to exert considerable influence on photographers across the United States from his New York publishing base. At this time, photographic journals and local amateur camera clubs were the primary vehicles for the advancement of artistic photography. The camera clubs followed a strict policy of not admitting professionals. Initially, Bay Area camera clubs had such a policy, but because of a quirk of history, San Francisco's camera club was to become the exception to the rule. In the 1880s a group

of amateur photographers called "The Knights of the Camera" formed the Pacific Coast Amateur Photographic Association (PCAPA), San Francisco's first camera club. The club excluded all professionals from membership, and by 1889 its roster had grown to seventy-five members. One of its prominent members was George W. Reed, a customs broker who had no intention of becoming a professional photographer. He did, however, allow one of his photographs of the Golden Gate to be sold on a royalty basis. Some members claimed that Reed, considered to be the most talented amateur on the West Coast,[11] had violated the Association's rule against professionalism, and in the storm of protest that followed, he was expelled from the club. Reed set about organizing a new club that offered membership on a broader basis, including professional members. He launched the California Camera Club in 1892, with seventy-five members—already as large as the PCAPA. The California Camera Club offered members darkroom facilities, meeting rooms, and a regular agenda of lectures and other activities such as lantern shows. Soon the club became so popular that it absorbed the entire membership of the PCAPA.[12] After the merger, the club continued its open admission policy so that from the mid-1890s onward professionals were an intrinsic part of the Bay Area's most important camera club.

By 1900 the California Camera Club had grown to be the largest in the United States, if not in the world. The first issue of the new club journal *Camera Craft* boasted: "Not less wonderful is the existence of the largest Camera Club in the world in the City of the Golden Gate."[13] This assertion was immediately challenged in the national press; it seemed impossible that a city with a population of approximately 300,000 inhabitants could support such a claim. The California Camera Club produced a list of 425 regular members while its nearest competitor, the New York Camera Club, could muster only 333. In the face of such evidence the editor of the *Photographic Times* conceded the California Camera Club was indeed the largest in the United States,[14] thereby establishing San Francisco as a preeminent creative center for photography.

•          •          •

Meanwhile in New York Stieglitz devoted his energies to creating an American photographic salon fashioned on the European model. In 1895 he proposed abolishing the annual joint exhibitions of photography, where technical, commercial, documentary, and art photography were exhibited together, in favor of a salon devoted solely to art photography. This stance forced Stieglitz's resignation from the *American Amateur Photographer*. Within a year he had launched a new publication called *Camera Notes*, the journal of the New York Camera Club, which was an amalgamation of New York's two largest camera clubs. But still Stieglitz was not satisfied; he wanted a salon devoted exclusively to Pictorial photography.

Even though San Francisco was a continent away from New York and half a world away from Europe, the aesthetic issues surrounding Pictorialism were of keen interest to California Camera Club members. As early as 1892 *The Pacific Coast Photographer*, a short-lived club journal that was a precursor to *Camera Craft*, published an article about art photography by Henry Peach Robinson entitled "Do Something Better."[15] Although California photographers were aware of Robinson's and Emerson's writings and had direct access to the Arts and Crafts Movement and the work of local Tonalists through the Mark Hopkins Institute of Art (later San Francisco Art Institute), it was not until 1900 that several local photographers produced accomplished Pictorial work.

Oscar Maurer was the first California Pictorialist to enjoy a national reputation. Maurer was the sole California entrant in the First Chicago Camera Club Salon of 1900, at which Stieglitz was one of three jurors. Maurer's photograph, *The Storm*, received critical acclaim not only

on the editorial pages of San Francisco's *Camera Craft* but from Eastern critics as well, one of whom wrote, " 'The Storm' . . . is one of the big things of the Exhibition."[16]

Spurred by his success in Chicago, Maurer argued that the California Camera Club should establish an annual photographic salon along the lines Stieglitz had urged before his resignation from the *American Amateur Photographer*. Maurer proposed the salon be held at the Mark Hopkins Art Institute, the most prestigious art venue in the city: "My own observation convinces me that among the vast amount of good material that professional and amateur photographers have produced on this Coast, enough may be secured to make a very creditable display."[17]

With the support of the California Camera Club, Maurer met on 18 August 1900 with Captain Robert H. Fletcher, curator for the Mark Hopkins Institute of Art. Within ten days the directors of the Institute had given their approval and the First San Francisco Salon was under way. Fourteen hundred prints were submitted, four hundred and seventy-five were accepted for the exhibition. However, apart from a few outstanding prints, the exhibition was perceived as a disaster.

In a *Camera Craft* review entitled "Important Lessons of the First Salon," Archibald Treat wrote: "I make the suggestion now, that the Hanging Committee of the Salon of 1902 be not only possessed of the necessary technical knowledge of what is good in photography, but that they be stony-hearted fellows as well."[18] In a total reversal of the pattern seen in the salons of Europe and the East Coast, where the amateur predominated, the first and second prizes for portraiture were awarded to two professional photographers, Arnold Genthe and Laura Adams. Genthe's work—mostly portraiture and pictures of Chinatown—was grouped together along one wall of an alcove. He was awarded the Salon's First Prize in Portraiture and *Camera Craft*'s Grand Prize.

Genthe had arrived in San Francisco from Germany only five years earlier, to take a position as tutor to the son of the German nobleman Baron von Schroeder. He purchased one of the new small-format cameras to photograph in Chinatown on his free days. Because the Chinese were reluctant to be photographed by a tall, unfamiliar Caucasian man, he perfected a technique of making candid pictures of the inhabitants without their knowledge. The pictures were published in *The Wave* in 1897 and 1898, encouraging him to pursue photography more seriously. *The Opium Fiend* [Cat. 9], one of his early images, was reprinted in the Pictorialist style that Genthe used in 1908 when he published his book *Pictures of Old Chinatown*. The print in the book is from the same negative as the print that Genthe exhibited at the salon, but differently cropped.[19] The published image is a less successful, nearly square format.

By 1897 the baron's son was ready for his university entrance examinations and Genthe's tutoring job was finished. He decided to remain in San Francisco and open a portrait studio on Sutter Street, where he would adapt his candid technique to portraiture. As Genthe later recalled:

> I thought, if they [my clients] were photographed in the unobtrusive manner which had worked so well with my shy and unsuspecting Chinese subjects . . . then something more of their spirit might be brought out by the camera. . . . We talked casually while I adjusted the camera, never letting them know just when I was taking their pictures.[20]

Genthe soon became an enthusiastic advocate of Pictorialism on the West Coast. In August 1901 he published an article entitled "The Rebellion in Photography" in which he attacked the professional photographer for producing work "just as commonplace, lifeless and photographic as it was twenty and thirty years ago." While the average contemporary professional

frequently produced "technically perfect prints . . . his negatives, however, have the same crude-ness, the same falseness of values, which distinguished the work of his predecessors." Because of the "absolute independence and iconoclastic energy of some enthusiastic amateur photog-raphers . . . a fundamental change was brought about in professional portrait photography." These "rebel" amateur photographers were not "satisfied with a faithful reproduction of the fea-tures or the microscopic rendering of detail. They want more: something of the soul, the in-dividuality of their sitter, must be expressed."[21]

Rebellion, as Genthe described it, was in the air. Pictorialism was sweeping California. Even though the First San Francisco Salon had been lambasted by the press, it acted as a cat-alyst for Bay Area photographers. The only Californian represented in the First Chicago Salon was Oscar Maurer, but in the Second, one year later, works by eleven Californians were accepted for exhibition in Chicago.[22] The Second San Francisco Salon also proved a vast improvement over the First. For the first time Californians had an opportunity to compare their work with some of the foremost Eastern Pictorialists, "and that this comparison was not entirely in our disfavor must be considered one of the greatest triumphs of our exhibition," wrote Genthe.[23] But most importantly, the Second San Francisco Salon uncovered new talent.

Anne W. Brigman (she signed her work "Annie W. Brigman" until 1911), a thirty-two-year-old painter from Berkeley who had only recently taken up photography, exhibited for the first time. The editors of *Camera Craft* commented, "Of the five prints on the wall the most interesting is [Brigman's] 'Portrait of Mr. Morrow,' which is one of the best portraits in the exhibition."[24] Brigman next exhibited her work at the First Los Angeles Salon, where her work was hung as a group. "Mrs. Brigman has shown wonderful improvement during the past few months, and her exhibit was one of the best on the walls,"[25] wrote a reviewer for *Camera Craft*.

In March 1902, soon after the second California Club Salon, one of San Francisco's most successful professional photographers, Laura Adams, announced her retirement from commer-cial photography and her marriage to Sidney Armer. In the 1890s Adams had been a leading member of a group of professional female photographers in Berkeley. The group included Emily Pitchford and Adelaide Hanscom, both of whom had been Laura Adams's classmates at the Mark Hopkins Institute of Art. In 1900 Adams left her compatriots in Berkeley to establish a successful studio in the Flood Building in downtown San Francisco. In the same year she pub-lished "The Picture Possibilities of Photography," one of the first articles to appear on the West Coast by a local photographer who advocated Pictorialism. In the article she condemned the careless professional and amateur who have brought photography to such a low state—to the point that "the camera has become the symbol of degenerate art. The unthinking photographer presses the button and leaves the rest to fate; and fate was ever a poor manager. . . . No machine can be a substitute for mind, and there are no short cuts to success."[26] *Portrait of a Young Woman* [Cat. 2] shows Adams at her best. It is an exquisite example of experimental Pictorialism in which, by the application of selective toning and lacquer, she managed to create subtle color hues on a gelatin silver paper.

After her marriage Laura Adams Armer did not give up photography entirely but con-tinued to contribute regularly to the photography journals and to participate in salons and ex-hibitions. During the First World War she again opened a commercial studio in Berkeley, work-ing for printers on projects that incorporated photography in graphic designs. In her later years she turned to making documentary films and writing children's books.

Armer is just one example of several Bay Area women who were among the leaders of the Pictorialist movement in California during the first two decades of this century. Photography

was one of the few areas of the graphic arts that provided a lucrative career opportunity for women. By 1900 more than thirty-five hundred women were employed as professional photographers in the United States, and by 1911 it was estimated that sixteen hundred woman were proprietors of photographic studios.[27] California women were particularly successful in this field. Los Angeles photographer and critic Helen L. Davie saw women "leading the way in pictorial portrait photography, a way which her brothers have found pleasant and are making haste to follow." Photography was also an exception to the usual rule where women would do the same work as a man but for a lower wage. Davie observed that women asked and received the highest prices for their work, "although [a woman] frequently charges as much for a single portrait as the average professional receives for a dozen, her engagement book is usually full."[28] Olga Dahl, a San Francisco photographer whose career spanned four decades, saw photography as a profession "where good taste, and tact are so important it would seem that the male should be at a positive disadvantage." And so they were. According to Dahl, "women have risen to eminence in portraiture with less effort, smaller investment, in a shorter time."[29]

·        ·        ·

Just a few months after Laura Adams Armer announced her withdrawal from photography, another resignation was announced: that of Alfred Stieglitz from *Camera Notes*, America's leading photographic publication. This was to change fundamentally the course of Pictorialism in America. The events in New York were closely followed in San Francisco. "We can but openly lament the withdrawal of Mr. Stieglitz and his associates from the publication," wrote the editor of *Camera Craft*. While no official reason was given for the resignations, the editors presumed they were compelled by the same reasons that had prompted other resignations:

> *In every organization of like character there creeps an element opposed to any departure that does not directly concern its welfare, looking only to its own social advancement, and relegating to the rear the earnest, yet modest, few who are the real life and soul of the organization.*
>
> *We regret deeply the turn affairs have taken in our sister city across the continent, and cannot but believe that the cause of Art Photography has suffered therefrom.*[30]

Perhaps more than any other club in America, members of the California Camera Club were sympathetic with the struggle. They had only recently achieved what Stieglitz was proposing—a salon devoted solely to art photography. Photographer William E. Dassonville wrote an article supporting Stieglitz's views. In the article Dassonville recounted how the prints of Pictorialist Edward Steichen were at first accepted by the jury of the *Champs de Mars Salon* for a fine art exhibition in Paris earlier that year, only to be subsequently rejected when the jury reversed its decision. The jury's about-face was widely cited by East Coast and European Pictorialists as an example of the prejudice, jealousy, and political intrigue that photographers faced when they tried to exhibit work in a general art show and, thus, why art photography needed a separate salon. Whatever doubts the French jury had about photography were not shared by Dassonville: "Whether photography is or is not an art is no longer a question. It is."[31]

Dassonville operated a professional portrait studio in San Francisco but found his artistic expression in landscape. *California Landscape* [Cat. 7] is an early example of his experimental platinotype-glycerin process. The landscape is clearly influenced by Tonalism and, except for the diffusion introduced by the printing process, is sharply focused. Dassonville continued to be

active in the Camera Club, giving lectures on art photography and becoming secretary in 1904. Always a photographic innovator, Dassonville turned from traditional Pictorial subjects to more contemporary architectural and industrial subjects in the 1920s, but he continued to print his images in the Pictorialist style. *San Francisco Ferry Super-Structure* [Cat. 35] is an example of his later work, printed on custom-made paper with a soft, velvety surface. Dassonville's photographic papers were so popular among Pictorialists that he eventually gave up his photographic studio to manufacture "Dassonville" paper full time.

·          ·          ·

West Coast photographers eagerly awaited the first issue, in January 1903, of Alfred Stieglitz's new quarterly, *Camera Work*. The review in San Francisco's *Camera Craft* was unstinting in its praise: "We hail the advent of *Camera Work* as a triumph of American art."[32] Published in New York, *Camera Work* was the journal for the newly formed Photo-Secessionists, a group of dedicated Pictorialists led by Stieglitz and fashioned after a London Pictorialist group called The Brotherhood of the Linked Ring. The Photo-Secessionists were to have a profound effect on photography throughout America, particularly in the Bay Area.

The term "Secession" was borrowed from the secession movements that had swept the art world in Europe during the last decade of the nineteenth century. Secessionists were nonconformist artists who rebelled against the artistic styles taught in the established academies. The first secession occurred in Munich in 1892, then later in Vienna and Berlin. The Munich Secession Exhibition of 1898 exhibited photography alongside painting, drawing, and sculpture, demonstrating sympathy with the aims of the Pictorialists. Stieglitz, who had resigned from the *American Amateur Photographer* and *Camera Notes* because he advocated a separate salon exclusively dedicated to art photography, immediately identified with the Secessionists' struggle: "They have broken away from the narrow rules of custom and tradition, have admitted the claims of the pictorial photograph to be judged on its own merits as a work of art independently, and without consideration of the fact that it has been produced through the medium of the camera."[33]

The editors of *Camera Craft* invited Stieglitz to explain the aims of the Secession to Californians. In August 1903 they published his response, which read in part, "The object of the Photo-Secession is not . . . to force its ideas, ideals and standards upon the photographic world, but an insistence upon the right of its members to follow their own salvation as they see it." There was nothing secret or mysterious about the Secession. The members were not bound together by some iron-clad oath, rather they "[were] free to do as they deem[ed] best."[34]

Stieglitz's willingness to tolerate diversity—even, reluctantly, professionalism—within the Secession was its greatest strength. The work had to qualify as artistic in Stieglitz's opinion, but his aesthetic was broad enough to encompass the dramatic, painterly photographs of Robert Demachy and Frank Eugene (whose images were so worked over with brushstrokes that they were often mistaken for drawings) as well as the work produced by "straight" photographers such as Frederick H. Evans, J. Craig Annan, and Stieglitz himself. In this atmosphere, Demachy could write that "[a] straight print may be beautiful . . . but it can not [sic] be a work of art,"[35] while Evans could hold the contrary opinion, that "to *dodge* a negative in any way whatever, except the spotting out of unavoidable mechanical defects, is not art, but a miserable confession of inability to treat photography as a true art. . . . Any artistic effect desired can be faithfully done by pure photography without any retouching whatever."[36] Hence, the Photo-Secession incorporated both Emerson's and Robinson's theories of Pictorial photography.

It was this freedom of expression that characterized the Pictorialist movement, an openness to experimentation with a variety of styles, processes, and materials. Not since the first decade after its invention had photography gone through such an intense period of exploration. What photography critic Charles Caffin saw in American Pictorialism was a "spirit of tireless experimenting." The search for new effects and the method of achieving them, "the partial success of one man or woman, prompting others to take up the experiment and carry it, perhaps, still further . . . have brought about an alertness to impressions, a spirit of investigation, and a pooling . . . of energies."[37]

Inspired by their East Coast counterparts, California Pictorialists were fastidious about matting, framing, and hanging their work. They also rebelled against the uniform standards of industrially manufactured photographic materials. The Pictorialists experimented with handmade papers and with exotic photographic chemistry to such an extent that these processes became a hallmark of the movement. Like Dassonville, some tried making their own papers and exploring nonsilver-based photographic processes such as platinum, palladium, iron, and uranium printing. Others rediscovered or perfected existing processes such as hand-coloring, paper negatives, photogravures, and carbon printing. And some like Laura Adams Armer explored new techniques such as selective toning, oil transfers, and gum-bichromate.

•          •          •

The Third San Francisco Salon (1903) included a collection of work by the Photo-Secessionists. "It is now our good fortune to have the opportunity to study the originals of pictures by such masters as Mrs. Käsebier, Steichen, Clarence White, Alfred Stieglitz, Joseph Keiley, William Dyer and of about a dozen other prominent and well-known Eastern workers," wrote Arnold Genthe.[38] The salon was considered a major success not only because of the Photo-Secessionist collection but also because of the improvement shown by local photographers. Much of the credit must be given to Genthe, who chaired the selection committee. Instead of the nearly five hundred works that had cluttered the walls of the Mark Hopkins Institute in the two previous exhibitions, only one hundred and seventy-five works were displayed.

When *Camera Work* published the first list of seventeen Fellows and thirty Associate Members of the Photo-Secession in July 1903, two Californians were listed among the Associates.[39] Oscar Maurer's name was no surprise since he had been a nationally prominent West Coast photographer for years, and *The Storm* had been singled out for praise at the First Chicago Salon, where Stieglitz had served as a juror. But how Anne Brigman came to be on the list so soon after taking up photography is a mystery. Brigman had only exhibited in two regional salons before mid-1903; she was very much a novice compared to several more prominent Bay Area Pictorialists who had not been invited to join the New York group.

Although California photographers were supportive of the aims of the Photo-Secessionists, only five were ever members. Anne Brigman was the only West Coast photographer to be elevated to Fellow.[40]

Even though Brigman and Maurer had become the first California members of the Photo-Secession, it was Adelaide Hanscom (who took over Laura Adams Armer's San Francisco studio) who attracted the attention of the press. By 1904 she had taken Blanche Cumming as a partner into her thriving photographic business and announced plans for a photographically illustrated edition of *The Rubáiyát of Omar Khayyám*. Writer Henrietta S. Breck was invited to "afternoon tea" at their studio in the Flood Building. About the visit she wrote, "Little groups

of critics and admirers were gathered here and there around pictures. . . . There was no dullness, no apathy. . . . Each guest had come for inspiration, or from an absorbing interest in the work." Near the end of the interview Breck, having screwed up her courage on the "refreshments," asked what she thought a sordid question: "Does it pay?" "Handsomely," was Hanscom's reply.[41] Just how handsomely we can gauge from Arnold Genthe's 1936 autobiography, *As I Remember*. Within a year of its opening, his studio was flourishing. "Payments were then made in gold, and I used to deposit the money in a box which I kept in a corner of my studio. One day I found that I had three thousand dollars in twenty-dollar gold pieces. . . . Box in hand I went to the Union Trust Company and opened my first bank account."[42]

Hanscom began to work on the *Rubáiyát* in earnest. She thought the famous poet of the Sierra Nevada, Joaquin Miller, would be perfect for the gray-bearded Persian sage. But the twenty-seven-year-old woman was understandably hesitant about approaching him. "It was no easy task to ask a stranger, especially a celebrated one, to pose for me. . . . Some careful maneuvering seemed necessary. I have since learned that even celebrities . . . are susceptible to flattery."[43] The old bard from Oakland was no exception and was quick to agree to be a subject. Miller's cooperation helped secure the assistance of two other prominent Bay Area poets, George Sterling and Charles Keeler. Suddenly the literary and artistic community was scrambling to be included in the project. San Francisco critic and author George Wharton James prevailed upon Miller to conjure up "an errand" that took him to Hanscom's studio. He talked himself into being photographed as a sultan.[44] The Tonalist painter Xavier Martinez, recently returned from

FIGURE 4
Adelaide Hanscom
*Untitled*
[Woman Holding Bowl], 1905
Illustration for
*The Rubáiyát of Omar Khayyám*
Photogravure
10.4 × 15.0 cm (4³⁄₃₂ × 5²⁹⁄₃₂ in.)
Wilson Collection

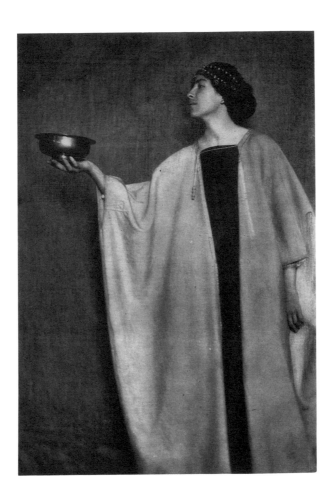

Paris, was recruited. Hanscom photographed him brandishing a sword, though she did not use this picture in the final selection.[45] She printed several versions of her studies before making the final selection for the book. Hanscom's untitled study for the twenty-first quatrain [Cat. 4] (which may be compared with Fig. 4, the final selection) shows substantially less manipulation than most of the other images included in the *Rubáiyát*. Many of them are combination prints in the style of Robinson, utilizing up to five negatives, and some show a copious amount of meticulous hand drawing. There are two male nude studies, perhaps the first ever published by a female photographer.[46]

The publication of the *Rubáiyát* was a focus of civic pride. Not only had a Bay Area artist produced the first photographically illustrated publication of one of the most popular books of the day but her models were local authors and artists. A headline in the *Oakland Tribune* on 19 March 1906 trumpeted, "The Berkeley Girl whose 'Omar' photos startle the literary critics."

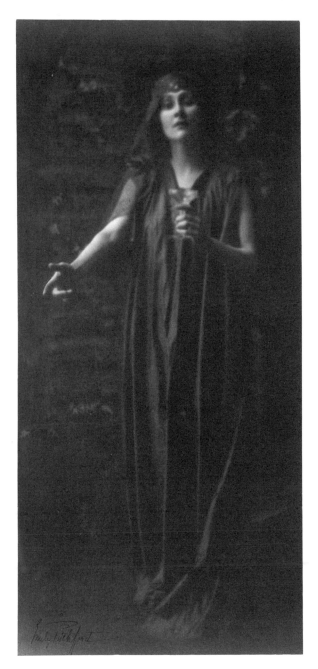

FIGURE 5
Emily Pitchford
*Annie Brigman*, c. 1908
Platinum print
16.0 × 34.8 cm (6⁹/₃₂ × 13²³/₃₂ in.)
Wilson Collection

·         ·         ·

From 1904 to 1906 the Bay Area Pictorialists thrived. Anne Brigman was preparing a portfolio to be published in *Camera Work*. Arnold Genthe was regularly depositing the contents of his cash box in the bank. Francis Bruguière, son of a wealthy San Francisco banker, had returned from New York determined to become a photographic artist. Dassonville and Maurer were busy operating their studios and making regular contributions to *Camera Craft*. Hanscom was basking in the warm glow of the favorably reviewed *Rubáiyát* and was about to be elected to the Photo-Secession. In April 1905 the California Camera Club extensively redecorated its rooms, boasting that it now had the best facilities of any camera club in the nation. California Pictorialists were in an ascendancy that was suddenly and dramatically to end.

Arnold Genthe recounts how, in the early morning of 18 April 1906, he was awakened by the sound of his Chinese porcelain collection crashing to the floor.

> *The whole house was creaking and shaking, the chandelier was swinging like a pendulum and I felt as if I were on a ship tossed about by a rough sea. . . .*
>
> *An ominous quiet followed. . . . I went to the top floor to see what had happened to my studio. The chimney had fallen through the roof, most of the book shelves had collapsed and the books were buried under mounds of plaster from the wall and ceiling.*[47]

The largest earthquake in the recorded history of the United States had virtually demolished San Francisco. Discovering all his cameras smashed, Genthe went to George Kahn's camera shop, where the dealer told him to take what he liked, as his business was likely to burn down. By midday fires had broken out throughout the city. The water mains had ruptured, so the National Guard dynamited buildings in a vain effort to halt the inferno. Genthe's home and studio were dynamited, but the fire swept through and incinerated it anyway.

All of his work was lost, except for the Chinatown negatives, which he had put into a bank vault at the suggestion of his friend Will Irwin. *San Francisco, April 18, 1906* [Cat. 10] was made on the morning of the first day of the fire. People sat in chairs calmly watching the approaching flames and "when the fire crept up close, they would just move up a block," Genthe wrote.[48]

The Camera Club's newly redecorated premises were entirely destroyed. Only four of its four hundred members managed to climb the stairs up the seven flights through the "plaster and debris to the club rooms," and they were forced by the conflagration to beat "a hasty departure with such of their belongings as they could easily carry."[49] Adelaide Hanscom was almost killed in an unsuccessful bid to rescue her work from the Flood Building. All her prints and negatives, except for a handful that were stored at her Berkeley home, were lost. All of Dassonville's and Maurer's work was lost as well. Francis Bruguière awoke to find his days of leisure at an end. His family's fortunes vanished in the smoke, and he was forced to take up photography as a profession. The Berkeley and Oakland women photographers, including Anne Brigman, were among the few who were not entirely wiped out.

Each photographer coped with the disaster in a different way. Dassonville left the city to work in the Sierra Nevada, eventually returning to reopen his commercial studio. The Camera Club temporarily relocated at the home of its assistant secretary, Miss A. K. Voy, and by August had found premises in a house at 2206 Steiner Street. Maurer, who had shared a studio with Genthe, opened his own on Le Roy Avenue in Berkeley. Genthe immediately took new premises in one of the few cottages that had survived the fire, but San Francisco was not the same for him after the earthquake and by 1911 he had moved to New York.

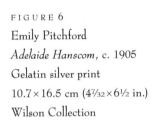

FIGURE 6
Emily Pitchford
*Adelaide Hanscom*, c. 1905
Gelatin silver print
10.7 × 16.5 cm (4⁷/₃₂ × 6½ in.)
Wilson Collection

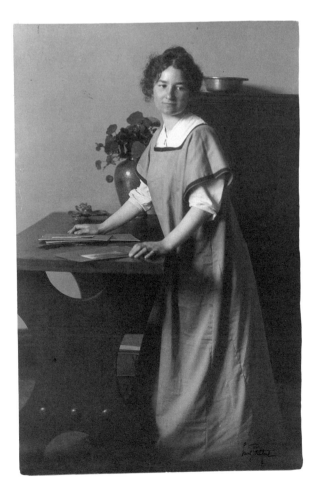

Adelaide Hanscom moved to Seattle and within a few months opened a studio there. After two prosperous years she gave up commercial work to marry Gerald Leeson, a mining engineer and ex-Mountie. The marriage was tragic for both of them, and her career effectively came to an end.

Emily Pitchford, Laura Adams Armer's Berkeley studio partner, continued to operate her commercial studio and show work at the national salons. Published in *Photograms of the Year, 1908*, Pitchford's *Suspense* [Cat. 12] shows the miniature portrait painter Marian Grace Norton and a friend at a window. Pitchford experimented with the new color autochrome process [Cat. 11] but is best known for her portraits of women Pictorialists: Fig. 5 (c. 1908) shows Anne Brigman in a theatrical costume; Fig. 6 (c. 1905) shows Hanscom at work in her studio; and

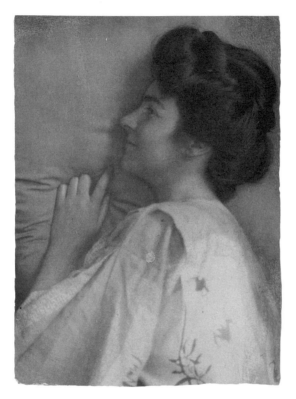

FIGURE 7
Emily Pitchford
*Self-Portrait*, c. 1908
Gelatin silver print
8.0 × 10.2 cm (3⁵/₃₂ × 4¹/₃₂ in.)
Wilson Collection

FIGURE 8
Emily Pitchford
*Dora and Guy Chalkley in their Garden on East Rand, Johannesburg, South Africa, in Costumes for Omar Khayyám*, 1911
Gelatin silver print
21.2 × 32.7 cm (8¹¹/₃₂ × 12⁷/₈ in.)
Wilson Collection

Fig. 7 (c. 1908) is a self-portrait. In 1911 she married William Leo Hussey (apparently not related to Bay Area photographer Henry Hussey) and moved to South Africa. She lived there for ten years, where she continued to work in the Pictorialist style [Fig. 8], and returned to the Bay Area in 1921.

Of all the Bay Area photographers, Anne Brigman seems to have been the least affected by the disaster. She had the reputation of a Bohemian free spirit. An interview in a 1913 San Francisco newspaper gives a taste of her lifestyle: "Her Sunday recreation is a run on the pebble beaches of San Mateo or Marin County barefoot. 'My feet feel fine afterward,' she explained. . . . 'My pictures tell of my freedom of soul, of my emancipation from fear. Why should I seek the artificial atmosphere of a court to secure a legal freedom from my husband when my soul is free without that relief?'"[50] Following the 1906 earthquake, her career continued its upward ascent unabated, climaxing as American Pictorialism reached its summit. In 1906 Brigman was elevated to Fellow of the Photo-Secession, the only person west of the Mississippi to hold such an honor. Over the years she was regularly included with the Secessionists in exhibitions at Stieglitz's gallery "291" as well as in other national and international salons. Two issues of *Camera Work* reproduced portfolios of her work. Sixteen of her prints were included in the "Pictorial Photography" exhibition at the Albright Art Gallery in Buffalo, New York, in 1910.[51] According to the editors of *Vanity Fair* there were "only some seven [photographers] in the whole world who really count." And they had it on good authority (most probably Stieglitz) "that Mrs. Brigman is one of the seven."[52]

Brigman was the most important American Pictorialist devoted to photographing the figure in the landscape. It was not a subject studied by East Coast Pictorialists, whose nudes were confined to the studio.[53] To Brigman the nude seemed natural and harmonious in the vast panoramas of California. Brigman's love of the outdoors was inspired by her mother, who took Brigman and her sisters on extended camping trips to the Sierra Nevada. As she recounted it years later, her conversion to photography was an event of almost religious significance that took place on one of these trips:

> *One day during the gathering of a thunderstorm when the air was hot and still and a strange yellow light was over everything, something happened almost too deep for me to be able to relate. New dimensions revealed themselves in the visualization of the human form as part of a tree and rock rhythms and I turned full force to the medium at hand and the beloved Thing gave me a power and abandon that I could not have had otherwise.*

The "beloved Thing" was not "the prescribed mediums and methods of academic lore, but . . . a despised and rejected thing, a camera."[54]

Brigman's Pictorialist style ran the spectrum from photographic realism to an impressionistic painterly style, as in such works as *The Heart of the Storm* [Cat. 15], which is often mistaken for a charcoal drawing. The guardian angel figure consoles the other woman within a protective stand of California western juniper trees. The western juniper tree, tortured by lightning and twisted by the wind, is a recurring image in Brigman's work, symbolizing independence and a graceful adaptation to the dissidence of life.[55]

Although she was inspired by pagan mythology, Brigman did not use props as did the Pre-Raphaelite painters. Her pictures are of contemporary women and have a modern feel compared with the anachronistic re-creations of past ages favored by such European Pictorialists as Baron Wilhelm von Gloeden, Guido Rey [Fig. 9], and Vicenzo Galdi. Her backgrounds were real, not studio sets or the results of combination printing as some of her critics charged.[56] She spent

FIGURE 9

Guido Rey

*Four Figures in Classical Robes,*

ca. 1885

Platinum print

14.9 × 8.8 cm (5⅞ × 3½ in.)

The J. Paul Getty Museum

summers camped in the Sierra Nevada with her models, who were her sisters, her friends, and herself. *The Dragon and the Pearl* [Fig. 10], for example, is probably a self-portrait.[57] Her Pictorial style and her disregard for academic standards caused controversy. Realist photographer Edwin Jackson attempted to have Brigman's *The Soul of the Blasted Pine* [Cat. 16] banned from exhibition. He was dismissive of her work: "Mrs. Brigman takes an unclothed scrawny dame . . . who looks as if she had not jerried to a square meal for a month, fixes her upon a piece of macadam somewhere, photographs the thrilling scene and calls it 'Squeal of the Rocks.'"[58] Brigman's models were athletic women, not the rotund boudoir figures of academic painting, and however "scrawny" they may have appeared to some of her reviewers, her models seem natural to us today. As one perceptive contemporary observed, "There is never any sense of nude bodies left unintentionally out-of-doors."[59] In an interview Brigman told a reporter, "I never use professional models. Many of them have told me that in the very act of posing they have experienced an exaltation of mind and soul."[60] This "exaltation of mind and soul" expressed so vividly by her models is the essence of her work.

•          •          •

The Photo-Secession was winding to a close by the time the Panama-Pacific International Exposition of 1915 brought the first examples of European modernism to San Francisco. Brigman

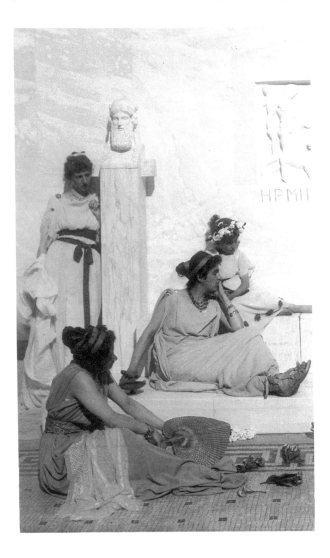

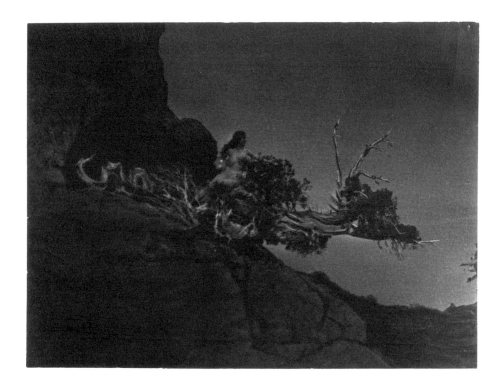

FIGURE 10
Anne Brigman
*The Dragon and the Pearl,* 1908
Gelatin silver print
24.0 × 17.8 cm (9⅞₁₆ × 7 in.)
Wilson Collection

and Bruguière were in charge of organizing the photographic section of the Exposition. Ultimately the Photo-Secessionists boycotted the Exposition because photography was exhibited in the Department of Liberal Arts, not Fine Arts.[61] *Court Verrochio, Italian Pavilion* [Cat. 25] is a hand-colored Pictorialist image by Bruguière, but he no doubt sensed the winds of change in the air. He published *San Francisco,* a book of urban studies in the Pictorialist style in 1918, but by 1919 he had moved to New York to open a commercial studio, and his artistic work turned toward abstract modernism.

In 1917 the California Camera Club organized its fifth and last salon at the Palace Hotel. The enthusiasm and energy of the early Northern California Pictorialists was on the wane, but the movement was far from dead. Reinforced by a second generation of photographers centered primarily in Southern California, Pictorialism continued to be practiced until the Second World War. However, without the dynamic leadership which Stieglitz had provided for the early Pictorialists, the movement split into several branches and evolved in new directions. Many of the new generation followed the lead of British Pictorialists, treading the well-worn path of traditional themes, content to continue to produce landscapes and portraits in the style of turn-of-the-century photographers. Their names are mostly forgotten today.

The followers of Robinson's line of Pictorialism were influenced by the booming motion-picture business. Their work was theatrical in character, reflecting the drama and defining the glamour of Hollywood. Louis Goetz, an active member of the California Camera Club and a frequent salon judge; Leopold Hugo, a professional photographer in Santa Cruz and La Jolla; and Arthur Kales, lawyer and business executive, were representative of these theatrical Pictorialists. The landscapes of Goetz and Hugo are often mysterious and sometimes brooding. Hugo worked with waxed-paper negatives [Cat. 23, 24], which gives his work a strong Tonalist character.

Kales's photographic subjects are primarily figure studies and portraits. Virtually all his models were professional actors and dancers, such as in Cat. 19 and Cat. 20. In his early San

Francisco work the models are posed in the landscape. Later he moved to Los Angeles, where he learned gum printing, and his work became theatrical, often utilizing Hollywood film sets. Success came effortlessly to him. Two of his friends, James N. Doolittle and Will Rabe, saw some of his work and suggested Kales send prints to the London Salon of 1916. "I collected a model and a few props and went through the agony of creation and negative making. Three prints were hung and one published in *Photograms of 1916.*"[62] Kales exhibited in London each year thereafter, as well as in other internationally recognized shows, until he died in 1936.

After the carnage of the First World War and the grim reality of the Spanish influenza epidemic that followed, the romantic subject matter that characterized turn-of-the-century Pictorialism no longer seemed appropriate. As a result, Pictorialists such as Dassonville, Johan Hagemeyer, Ernest Pratt, and Henry Hussey became modernists in subject matter and perspective although they remained Pictorialists in style. Cityscapes and industrial subjects dominated in the work of these photographers. They investigated the interplay of light and shadow in an exploration of geometric shapes and repetitive patterns.

The final branch of the second-generation Pictorialists, some of whom became internationally renowned, gave up Pictorialism in favor of "straight" photography. For the most part they were attracted to modernist themes and subjects in the 1920s, abandoning the Pictorialist style altogether in the early thirties. Imogen Cunningham, Dorothea Lange, Helen E. MacGregor, Alma Lavenson, John Paul Edwards, and—as unlikely as it may seem—even Edward Weston and the young Ansel Adams began as Pictorialists. Ansel Adams wrote: "I am more than ever convinced that the only possible way to interpret the scenes hereabout is through an impressionistic vision. . . . Form, in a material sense, is not only unnecessary, but sometimes useless and undesirable."[63] *Mt. Robeson from Mt. Resplendent* [Cat. 39], by Adams, is a Pictorial landscape printed on Dassonville paper, and on the mat Adams wrote:

> *To my friend W. E. Dassonville/ I want you to have this print as an expression/ of my appreciation/ as you see, I have been able to/ achieve results with a most difficult/ subject, in a manner that I know/ could not be gotten with any other/ photographic paper—/ [signed] Ansel E. Adams*

Ansel Adams, Cunningham, Edwards, Sonia Noskowiak (former receptionist at Hagemeyer's studio), and Willard Van Dyke (former assistant to Anne Brigman) gathered on 8 November 1932 at 683 Brockhurst Street in Oakland to establish a new group devoted to "straight" photography. They called themselves Group f/64, standing for the smallest lens diaphragm opening to ensure sharp focus.[64] They saw photography as possessing its own unique aesthetic, independent of the other arts. Weston had invited Hagemeyer to join f/64, but he declined, characterizing the majority of the group as "photographer youngsters, little squirts."[65] It is ironic that Group f/64 was conceived at the Brockhurst Gallery, which was Anne Brigman's former studio and the West Coast temple of Pictorialism.

A photograph taken about 1925 shows a comic tableau of Anne Brigman as *Saint Anne of the Crooked Halo* [Fig. 11],[66] surrounded by a circle of adoring youth. The worshipers include Edward Weston, Imogen Cunningham and her husband Roi Partridge, Roger Sturtevant, and Johan Hagemeyer. In time, just as the early Pictorialists had rebelled against the conventions of their day, these young photographers would reject Robinson's dramatic narrative style, Emerson's soft-focus naturalism, the Tonalists' atmospheric effects, and the exotic processes inspired by the Arts and Crafts movement. But they would not deny their Pictorial apprenticeship and

the inspiration of Anne Brigman, Alfred Stieglitz, and the other members of the Photo-Secession.

Pictorialism was all but over by the end of the Second World War. "Straight" photography claimed victory. But who really won? If we look at photography today, have we not returned to an age of experimentation? Do not modern artists challenge our concepts of what photography is? Are not Anne Brigman's words as true today as they were almost a century ago?

> *Are we not living in an age in which we are free reasonably so to do as we please? Who is going to limit himself to one tool when two or more will make his workmanship more beautiful? I claim the right to run the gamut from a lens to a shoe-brush to gain a desired effect.*[67]

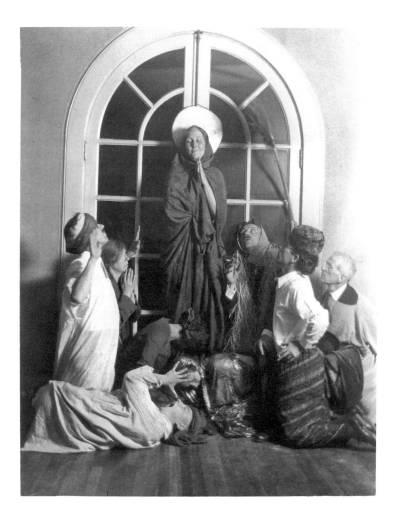

FIGURE 11
Unknown American
*St. Anne of the Crooked Halo*, 1925
Gelatin silver print, toned
24.4 × 19.3 cm (9⅝ × 7⅝ in.)
The J. Paul Getty Museum

# NOTES

1    Laura M. Adams, "The Picture Possibilities of Photography," *Overland Monthly* 36, no. 213 (September 1900): 241.

2    Most of the basic surveys of the history of photography devote a chapter to Pictorialism. For an in-depth study see Weston J. Naef, *The Collection of Alfred Stieglitz: Fifty Pioneers of Modern Photography* (New York: Metropolitan Museum of Art, 1978). For a less sympathetic view see Ulrich F. Keller, "The Myth of Art Photography: A Sociological Analysis," *History of Photography* 8, no. 4 (October–December 1984) and "The Myth of Art Photography: An Iconographic Analysis," 9, no. 1 (January–March 1985). The pioneering work on Pictorialism in California was done by Margery Mann, who organized the exhibition "California Pictorialism" (January 7–February 27, 1977) for the San Francisco Museum of Modern Art; see her exhibition catalogue, *California Pictorialism* (San Francisco: San Francisco Museum of Modern Art, 1977). See also Katrina Miottel, "'Rebellion in Photography': Northern California Photographers at the Turn of the Century" (unpublished manuscript, Stanford University, June 1985); and Therese Heyman, "Encouraging the Artistic Impulse: The Second Generation: 1890–1925," in *Watkins to Weston: 101 Years of California Photography, 1849–1950* by Thomas Weston Fels, et al. (Santa Barbara: Santa Barbara Museum of Art with Roberts Rinehart Publishers, 1992).

3    Henry Peach Robinson, *Pictorial Effect in Photography* (London, 1869. Reprint. Pawlet, Vermont: Helios, 1971): 9–10, 21.

4    Ibid., 78. Robinson was trying to distinguish his work from commercial travel photographers such as Francis Frith, who saw the clarity of image as the "cornerstone" of photography. To Frith the photographic process offered a "new spiritual quality . . . a charm of wonderful freshness and power . . . quite independent of general or artistic effect and which appeals instinctively to our readiest sympathies." Francis Frith, "The Art of Photography," *The Art Journal* 5 (1859): 72.

5    *Humphrey's Journal of Photography* 9 (1857): 92–93, cited in Beaumont Newhall, *The History of Photography: From 1839 to the Present* (New York: Museum of Modern Art, 1982): 74.

6    Peter Henry Emerson, *Naturalistic Photography: for Students of the Art* (London: 1889): 150.

7    Henry Peach Robinson, *The Elements of a Pictorial Photograph* (Bradford, England: Percy Lund & Co., Ltd., 1896): 87. Within two years of publishing *Naturalistic Photography*, Emerson repudiated his book in *The Death of Naturalistic Photography* (privately published, 1890).

8    Wanda M. Corn, *The Color of Mood: American Tonalism 1880–1910* (San Francisco: M. H. de Young Memorial Museum and the California Palace of the Legion of Honor, 1972): 5.

9    *Amateur Photographer* 1 (1884): 3, cited in Naef, 16, 18.

10   Newhall, 146.

11   Mann, Margery. *California Pictorialism*. San Francisco: San Francisco Museum of Modern Art, 1977, 15.

12   L. J. Stellmann, "California Camera Club," *Photo-Era* 29 (October 1912): 171–174. San Francisco's California Club became a member of the Pacific League of Camera Clubs, a loose association of West Coast photography clubs. The other Northern California clubs in the League were the Sacramento Camera Club, Vacaville Camera Club, Santa Cruz Camera Club, Watsonville Camera Club, Alameda Camera Club, and the Photographic Art Association (San Francisco), which merged with the California Camera Club in 1900 (*Camera Craft* 1 [July 1900]: 121). The other members of the League were the Los Angeles Camera Club and the Redlands Camera Club from California; and from Oregon, the Oregon Camera Club (of Portland), the Tacoma Camera Club, and the Pendleton Camera Club. James W. Erwin, "A Pacific League of Camera Clubs," *Camera Craft* 1 (May 1900): 15.

13   Editorial, *Camera Craft* 1 (May 1900): 26, cited in Miottel, 2.

14   Editorial, *Camera Craft* 1 (August 1900): 192, but *The Photographic Times* petulantly demanded the California Camera Club still prove it was the largest in the world.

15   *Pacific Coast Photographer* 1 (1892): 214. *The Pacific Coast Photographer* was only published for three years, from 1892 to 1895.

16   William B. Dyer, "The Chicago Salon," *Camera Notes* 4 (July 1900): 71. I can locate no surviving copies of *The Storm* in the holdings of the major California photographic collections, a situation which underscores the rarity of early California Pictorialist photography. Apparently no California collector accumulated and preserved the work of early California Pictorialists, as Stieglitz had done for the Photo-Secessionists.

17   Oscar Maurer, "A Plea for Recognition," *Camera Craft* 1 (June 1900): 60. See also *Camera Craft* 1 (September 1900): 264.

18   Archibald Treat, "Important Lessons of the First Salon," *Camera Craft* 2 (February 1901): 291.

19   Arnold Genthe, *Pictures of Old Chinatown* (New York: Moffat, Yard and Company, 1908). The images from the book are printed in the Pictorialist style, quite different from the photo-journalistic treatment they had received when published in *The Wave* and *Camera Craft*.

20   Arnold Genthe, *As I Remember* (New York: John Day, 1936): 41.

21   Arnold Genthe, "The Rebellion in Photography," *Overland Monthly* 43 (August 1901): 93–96.

22   Louis B. Lamb, "The Second Chicago Photographic Salon," *Camera Craft* 3 (October 1901): 236.

23   Arnold Genthe, "What Various Prominent Critics Have to Say of

the Second San Francisco Photographic Salon Just Passed," *Camera Craft* 4 (February 1902): 171.

24 *Camera Craft* 4 (January 1902): 122. For an in-depth biography of Brigman see Therese Thau Heyman, *Anne Brigman, Pictorial Photographer/Pagan/Member of the Photo-Secession* (Oakland, Calif.: The Oakland Museum, 1974) and Naef, *The Collection of Alfred Stieglitz*.

25 "A Few Words of Criticism Upon the Work of Each Exhibitor, Leveled in a Kindly Spirit by the Editor, with Reproductions of Striking Pictures," *Camera Craft* 5 (June 1902): 46, article illustrated with Brigman photograph.

26 Adams, 241.

27 C. Jane Gover, *The Positive Image: Women Photographers in Turn of the Century America* (Albany, N.Y.: The State University of New York Press, 1988): 17; and H. Snowdon Ward, *Photograms of the Year, 1911*, 34, cited in Naef, *The Collection of Alfred Stieglitz*, 98.

28 Helen L. Davie, "Women in Photography," *Camera Craft* 5 (August 1902): 130, 134.

29 Olga Dahl, "Women in Commercial Photography," *Camera Craft* 31 (December 1924): 577–580, cited in Palmquist, *Shadowcatchers*, 94–95.

30 *Camera Craft* 5 (June 1902): 83.

31 William E. Dassonville, "Individuality in Photography," *Overland Monthly* 40, no. 4 (October 1902): 339–345. See also Naef, *The Collection of Alfred Stieglitz*, 115.

32 Editorial, *Camera Craft* 6 (February 1903): 168.

33 Alfred Stieglitz, "Pictorial Photography," *Scribner's Magazine* 26 (November 1899): 528–537, cited in Naef, *The Collection of Alfred Stieglitz*, 63.

34 Alfred Stieglitz, "The Photo-Secession—Its Objects," *Camera Craft* 7 (August 1903): 81, 82.

35 Robert Demachy, "On the Straight Print," *Camera Work*, no. 19 (1907): 21.

36 Frederick H. Evans, *British Journal of Photography* 33 (1886): 20–21, cited in Newhall, 147, 150.

37 Charles Caffin, "The Development of Photography in the United States," *Art in Photography* (London: The Studio, 1905): US4.

38 Arnold Genthe, "The Third San Francisco Salon," *Camera Craft* 7 (November 1903): 207.

39 "The Photo Secession," *Camera Work* 3 (July 1903): no page number.

40 Oscar Maurer's work was never published in *Camera Work*, and he never exhibited with the other Secessionists at the Little Gallery of the Photo-Secession, known by its street address as "291" (although the work of his brother, painter Alfred Maurer, was exhibited). By 1905 Oscar Maurer's name had been dropped from the membership roster. In 1906 Brigman was elevated to Fellow. In November 1906 one of Adelaide Hanscom's images was hung in a members' exhibition at "291," suggesting she was a member at that time, although there is some authority for believing that she did not officially join until 1908. See Dimitri Shipounoff's article, "Adelaide Hanscom: A California Pictorial Photographer," in *Adelaide Hanscom Leeson: Pictorialist Photographer, 1876–1932* by Dimitri Shipounoff and Gail Marie Indvik (Carbondale: Southern Illinois University, 1981): 12. Hanscom's name does not appear in

the April 1909 membership list, but the name of San Francisco professional photographer Francis Bruguière appears as an Associate Member for the first time (*Camera Work*, no. 26 [April 1909]: 43). Although Bruguière remained a member of the Photo-Secession, he was inactive. He exhibited with the Secessionists only once, in Buffalo in 1910, and one of his images was reproduced in *Camera Work* in 1916. The last person to join the Photo-Secession, in 1912, was Karl Struss, a resident of New York at the time, although he moved to Southern California after the First World War, and became one of Los Angeles's leading Pictorialists.

41 Henrietta S. Breck, "California Women and Artistic Photography," *Overland Monthly* 43 (February 1904): 97.

42 Genthe, *As I Remember*, 51.

43 *Seattle Post Intelligencer* (September 30, 1906), cited in Shipounoff, 16.

44 George Wharton James, "Books and Writers," *Sunset Magazine* 16 (March 1906): 507–510.

45 "Adelaide Hanscom made some photos of myself for the Rubáiyát which were never used—I do not know the reason—except that the one published is terribly feeble—and perhaps mine was too ferocious." Letter from Martinez to Miller, reprinted in Juanita Miller, *My Father C. H. Joaquin Miller, Poet* (Oakland: Tooley-Towne, 1941): 155, cited in Shipounoff, 16. Martinez posed for the sixtieth quatrain.

46 Her outdoor male nudes predate Cunningham's 1915 pictures of Roi Partridge on their honeymoon, which have been claimed to be the earliest such pictures by a woman.

47 Genthe, *As I Remember*, 87–88.

48 "Of the pictures I had made during the fire, there are several, I believe, that will be of lasting interest. There is particularly the one scene that I recorded the morning of the first day of the fire (on Sacramento Street, looking toward the Bay) which shows, in a pictorially effective composition, the results of the earthquake, the beginning of the fire and the attitude of the people. On the right is a house, the front of which had collapsed into the street. The occupants are sitting on chairs calmly watching the approach of the fire. Groups of people are standing in the street, motionless, gazing at the clouds of smoke. When the fire crept up close, they would just move up a block. It is hard to believe that such a scene actually occurred in the way the photograph represents it. Several people upon seeing it have exclaimed, 'Oh, is that a still from a Cecil De Mille picture?' To which the answer has been, 'No, the director of this scene was the Lord himself.'" Genthe, *As I Remember*, 94.

49 "California Camera Club," *Camera Craft* 13 (July 1906): 259.

50 "Fear Retards Woman, Avers Mrs. Brigman," *San Francisco Call*, 8 June 1913: 9, also quoted in Heyman, "Encouraging the Artistic Impulse," 64.

51 The Buffalo exhibition of six hundred works is considered to be Stieglitz's swan song. The show was meant to "sum up the development and progress of photography as a means of pictorial expression." Introduction to the Catalogue of the International Exhibition (Buffalo: The Buffalo Fine Arts Academy/Albright Art Gallery, 1910); quoted in Naef, *The Collection of Alfred Stieglitz*, 186.

52    "Works of Nature and Works of Art," *Vanity Fair* (June 1916): 51.

53    One print in Stieglitz's collection, *The Bat* by Gertrude Käsebier (a 1904 print from a 1902 negative), is similar to Brigman's work. Stieglitz's handwritten note on the back of the print reads: "White claims that he and Mrs. K. did this together./ That it was his idea. That Mrs. White is the model: Photographed on Mrs. K's visit to Newark, Ohio/ A. S." Naef, *The Collection of Alfred Stieglitz*, 391.

54    Anne Brigman, "Awareness," *Design for Arts in Education* 38 (June 1936): 17, 18.

55    In Brigman's own words: "I love wild trees that stand apart and stark . . . / Beaten by wind and rain and stinging hail . . . / Nurtured by centuries of sun . . . and dark / Of countless nights. Trees that withstand the flail / Of lightnings and the bellowing thunder's roar . . . / Aloof . . . supreme . . . unmindful of the storms. / . . . For grace and courage in this human life . . . / Grant us the beauty, trees have found through strife." Anne Brigman, *Songs of a Pagan* (1949), cited in Heyman, *Anne Brigman*, 10.

56    In reply to a critic from the *New York Mail,* 20 November 1907, who commented that "The Thaw" had to be done in the studio, "As it is impossible to suppose that the lady posed in this condition on the mountain side in winter," Brigman wrote a detailed reply that concluded: "The negative of 'The Thaw' was made in glowing midsummer, and there was not more than a million acres of snow in sight!" *Camera Craft* 16 (March 1908): 87–88, cited in Palmquist, 54.

57    The profile is similar to *The Enchanted Tree*, a self-portrait in the collection of the Metropolitan Museum in New York. The picture dates from before 1911 by which time Brigman had cut her hair. Of significant note is the retouching of the bush to cover the left breast: Imogen Cunningham relates that Brigman had her breast amputated after a sailing accident. Heyman, *Anne Brigman, Pictorial Photographer/Pagan/Member of the Photo-Secession*, 2.

58    *San Francisco Call*, 18 October 1908, p. 17, col. 4, quoting Edwin R. Jackson. Citation also quoted in Heyman, *Anne Brigman,* 4.

59    Hamilton, Emily J. "Some Symbolic Nature Studies from the Camera of Annie W. Brigman," *Craftsman* 12 (September 1907): 660–664.

60    *San Francisco Call*, 8 June 1913: 9.

61    Naef, *The Collection of Alfred Stieglitz*, 201. See Mann, *California Pictorialism*, 25. Edward Weston saw the Modernists for the first time at the Panama-Pacific International Exposition, and it left a deep impression on him. See Weston J. Naef, "Edward Weston: The Home Spirit and Beyond," in Susan Danly and Weston J. Naef, *Edward Weston in Los Angeles* (San Marino, Calif.: The Huntington Library and Art Gallery, 1986): 21. Weston was indignant that the "exquisite" prints he saw by Photo-Secessionists Clarence H. White, Karl Struss, and Anne Brigman were "hidden away in the Liberal Arts Building" rather than displayed in the Palace of Fine Arts with the other graphic arts. "Photography as a Means of Artistic Expression, 1916," lecture by Edward Weston at the College Women's Club, Los Angeles, 18 October 1916, repr. in Peter C. Bunnell, ed., *Edward Weston on Photography* (Salt Lake City: Peregrine Smith Books, 1983), 18–21.

62    Arthur F. Kales, *Camera Craft* 37 (December 1930): 575.

63    Mary Street Alinder and Andrea Gray Stillman, eds., *Ansel Adams: Letters and Images 1916–1984* (New York: Little, Brown and Company, 1988), 7–8.

64    Van Dyke suggested the name "U S 256" for the group, "256" being the smallest f-stop in the Uniform System. Adams told Van Dyke nobody used the uniform system any longer, suggesting instead its equivalent—f/64. "He drew it out, and you could suddenly see the cover of the catalogue." Novakov, *John Paul Edwards*, n.p. The views of f/64 were revolutionary for their time but hardly new. They are a recapitulation of the beliefs of Francis Frith and other great nineteenth-century expeditionary photographers who were advocates of the "straight" print.

65    Richard Lorenz, *Johan Hagemeyer: A Lifetime of Camera Portraits* (Tucson: Center for Creative Photography, University of Arizona, June 1982) The Archive, series no. 16: 18.

66    The title is inscribed on the reverse of another image from the same session featuring Anne Brigman alone (in the collection of Susan Ehrens). The caption on that print credits Dorothea Lange as the photographer but dates the picture 1913, five years before Lange came to California. Various other dates and makers have been suggested. It could be 1923, when Hagemeyer and Weston had a studio in San Francisco for six months, or after 1926, when Weston returned from Mexico. See Therese Thau Heyman, "Perspective on Seeing Straight," *Seeing Straight: The f64 Revolution in Photography* (Oakland: The Oakland Museum, 1992): 25, where the image is attributed to Anne Brigman or Roi Partridge and titled "Anne Brigman and Friends in Costume," c. 1920.

67    Anne Brigman, "Starr King Fraternity Exhibition," *Camera Craft* 10 (April 1905): 229.

# Northern California

Plates

1
Laura Adams Armer
*The Close of Day*, ca. 1919
Gelatin silver print
22.7 × 20.0 cm (8¹⁵⁄₁₆ × 7⅞ in.)
Collection of James Marrin

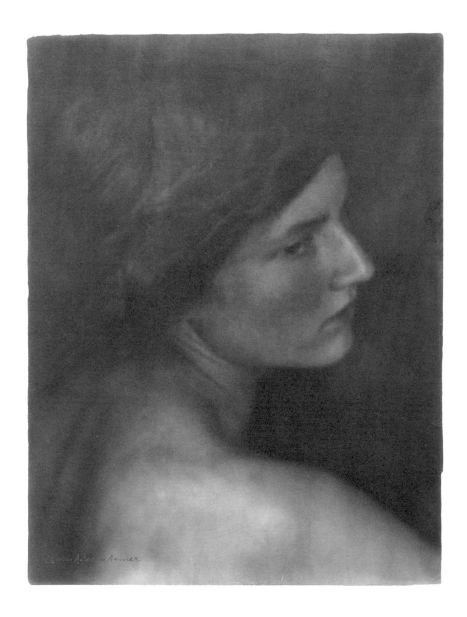

2
Laura Adams Armer
*Portrait of a Young Woman*,
1902–3
Gelatin silver print, toned,
and lacquered
24.2×31.4 cm (9½×12⅜ in.)
Wilson Collection

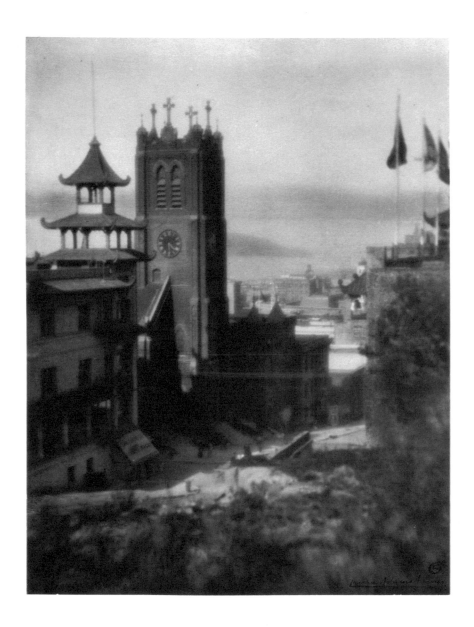

3
Laura Adams Armer
*View of San Francisco,*
1902–6
Gelatin silver print
18.5 × 23.7 cm (7⁹/₃₂ × 9¹¹/₃₂ in.)
Wilson Collection

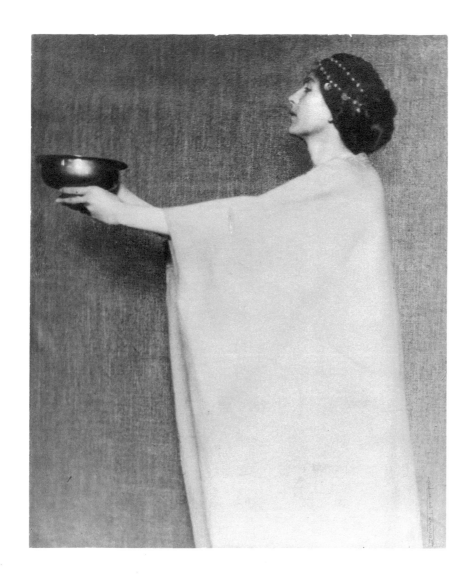

4
Adelaide Hanscom
Illustration for *The Rubáiyát of
Omar Khayyám*, c. 1905
Gelatin silver print
24.1×28.9 cm (9½×11⅜ in.)
Collection of James Marrin

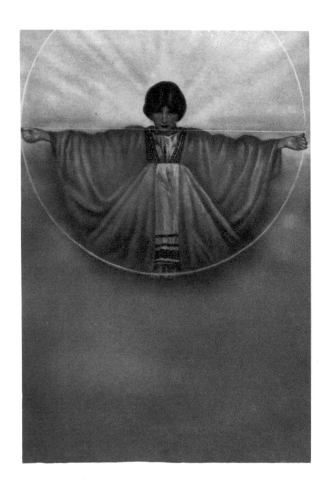

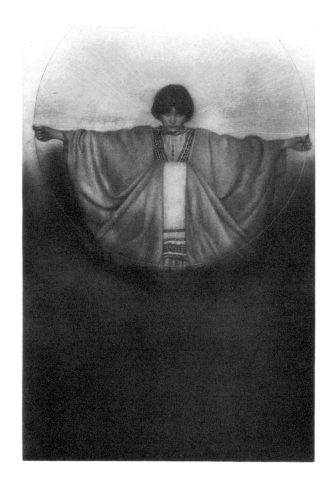

5a
Adelaide Hanscom and
Blanche Cumming
Illustration for *The Rubáiyát of
Omar Khayyám*, neg. 1905,
published 1912
Collotype
16.8 × 11.5 cm (6¹⁹/₃₂ × 4½ in.)
The J. Paul Getty Museum

5b
Adelaide Hanscom
Illustration for *The Rubáiyát of
Omar Khayyám*, 1905
Photogravure
11.7 × 17.0 cm (4⁹/₃₂ × 6¹¹/₁₆ in.)
Wilson Collection

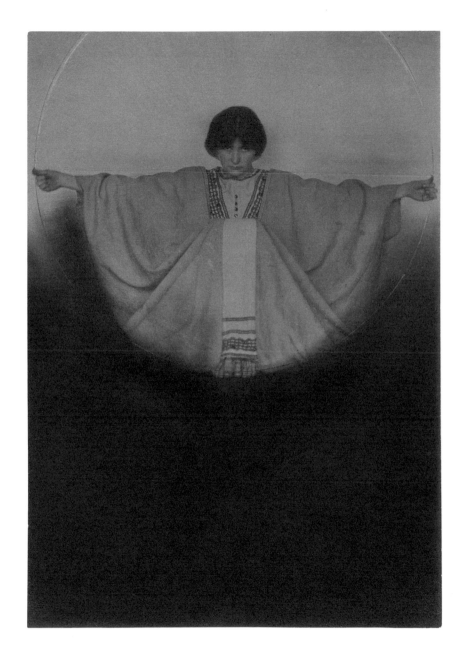

6
Adelaide Hanscom
Illustration for *The Rubáiyát of
Omar Khayyám*, c. 1905
Gelatin silver bromide print
11.5 × 16.1 cm (4½ × 6¹¹⁄₁₆ in.)
Wilson Collection

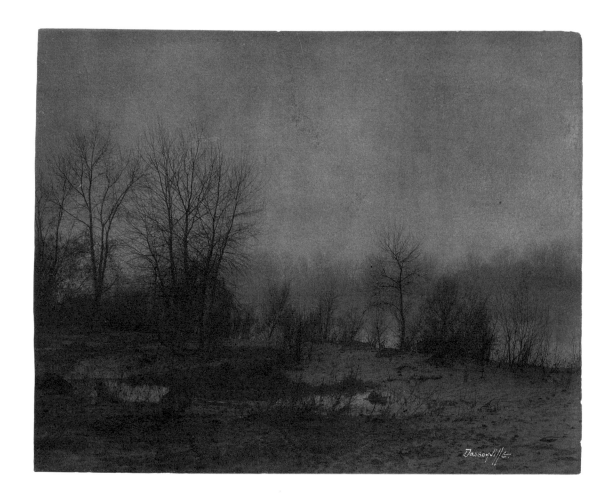

7
William E. Dassonville
*California Landscape*, c. 1900
Platinotype
24.3 × 18.9 cm (9 9/16 × 7 7/16 in.)
Wilson Collection

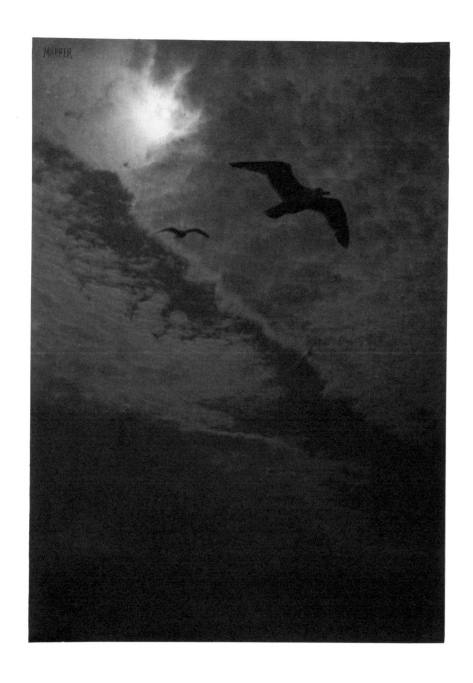

8
Oscar Maurer
*Flying Gulls*, c. 1920
Gelatin silver print
34.6 × 27.2 cm (13⅝ × 10 ²³⁄₃₂ in.)
The J. Paul Getty Museum

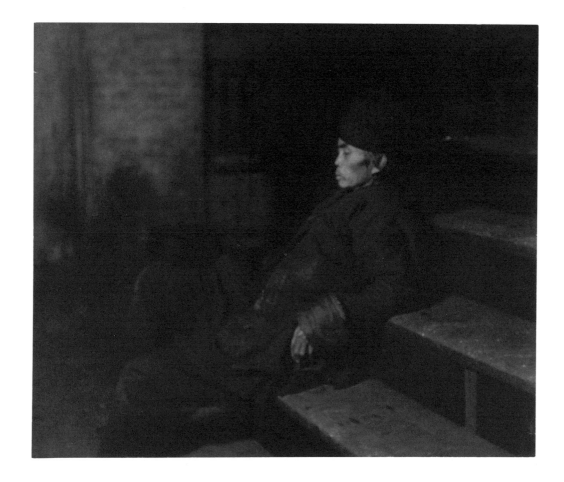

9
Arnold Genthe
*The Opium Fiend,* 1905
Gelatin silver print
25.4 × 30.8 cm (10 × 12⅛ in.)
The J. Paul Getty Museum

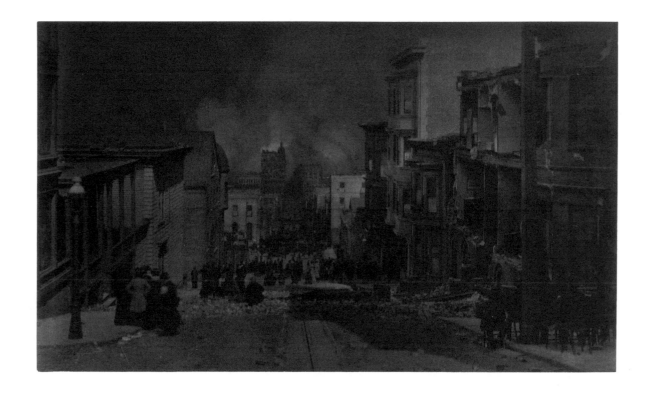

10
Arnold Genthe
*San Francisco, April 18, 1906*,
printed 1920s
Gelatin silver print
19.5 × 33.4 cm (7¹¹/₁₆ × 13⁵/₃₂ in.)
The J. Paul Getty Museum

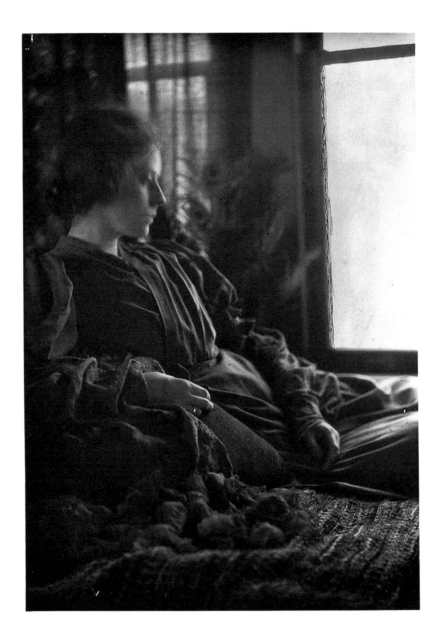

11
Emily Pitchford
*Seated Woman*, c. 1910
Autochrome
12.6×17.6 cm (4³¹⁄₃₂×6¹⁵⁄₁₆ in.)
Wilson Collection

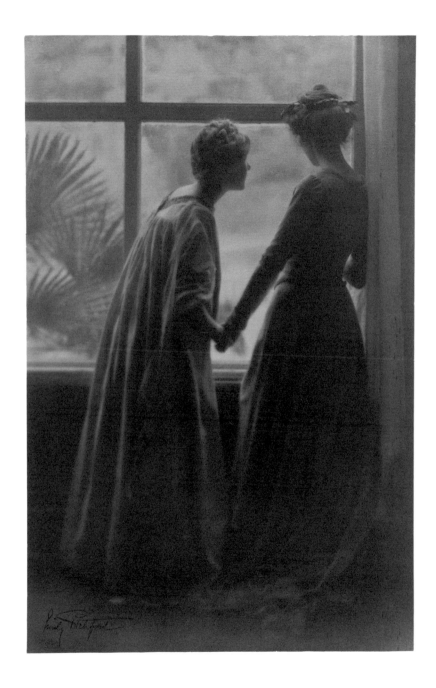

1 2
Emily Pitchford
*Suspense*, 1908
Gelatin silver print
19.7×29.9 cm (7¾ × 11²⁵⁄₃₂ in.)
Wilson Collection

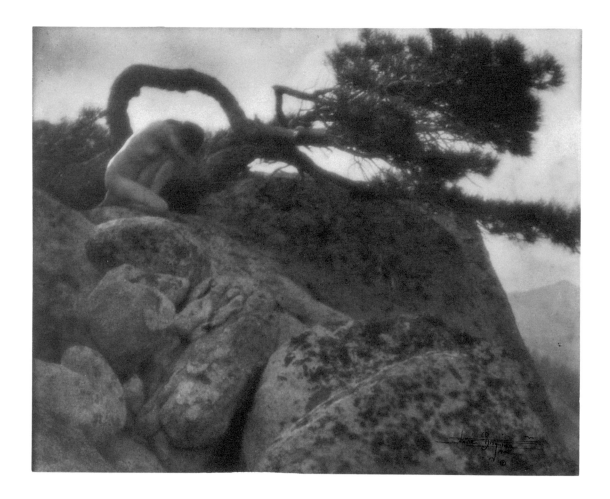

13
Anne Brigman
*The Lone Pine*, c. 1908
Gelatin silver print
19.3 × 24.6 cm (7$^{19}$/$_{32}$ × 9$^{11}$/$_{16}$ in.)
The J. Paul Getty Museum

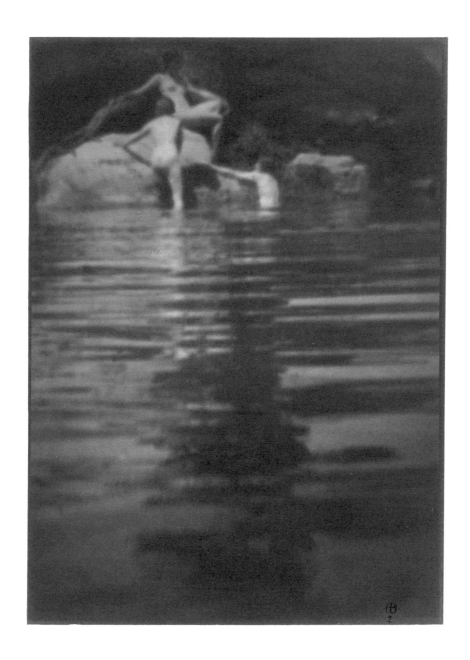

1 4
Anne Brigman
*The Magic Pool*, 1906
Gelatin silver print
18.0 × 25.0 cm (7³/₃₂ × 9²⁷/₃₂ in.)
Wilson Collection

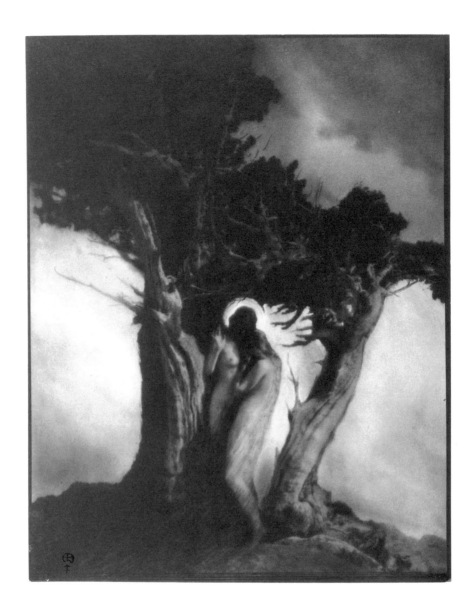

15
Anne Brigman
*The Heart of the Storm*, c. 1915
Gelatin silver print
19.1×24.5 cm (7½×9²¹⁄₃₂ in.)
Wilson Collection

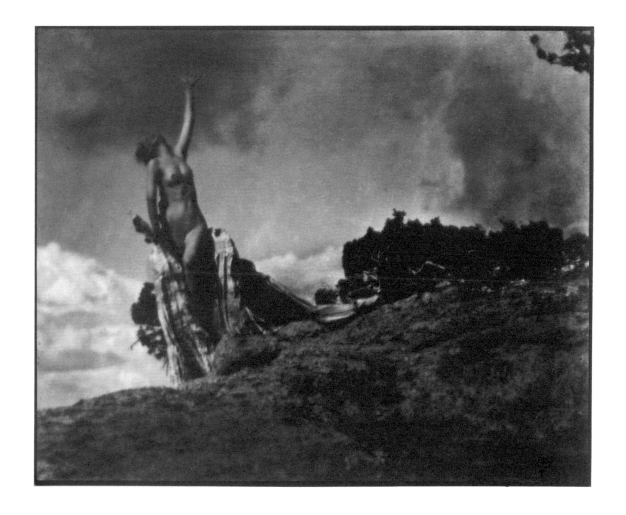

16
Anne Brigman
*The Soul of the Blasted Pine,*
1907
Gelatin silver print
24.4 × 19.5 cm (9 5/8 × 7 11/16 in.)
Wilson Collection

17
Willard Worden
*Sand Dunes*, c. 1915
Gelatin silver print
33.9 × 27.0 cm (13¹¹/₃₂ × 10⅝ in.)
Wilson Collection

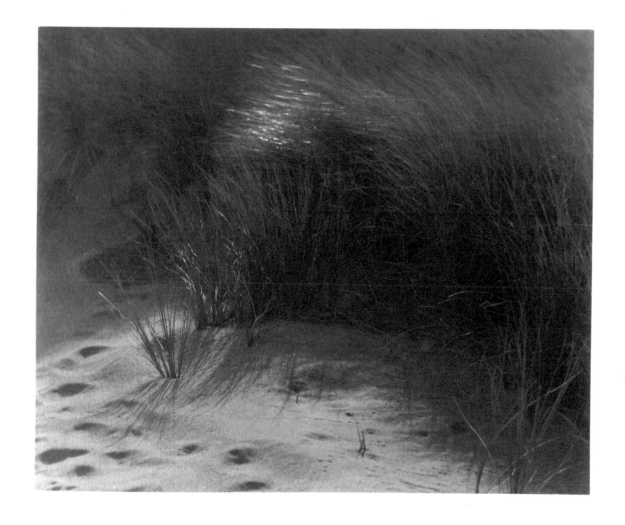

18
William E. Dassonville
*Beach Grass*, c. 1920
Gelatin silver print
20.3 × 25.2 cm (8 × 9¹⁵⁄₁₆ in.)
The J. Paul Getty Museum

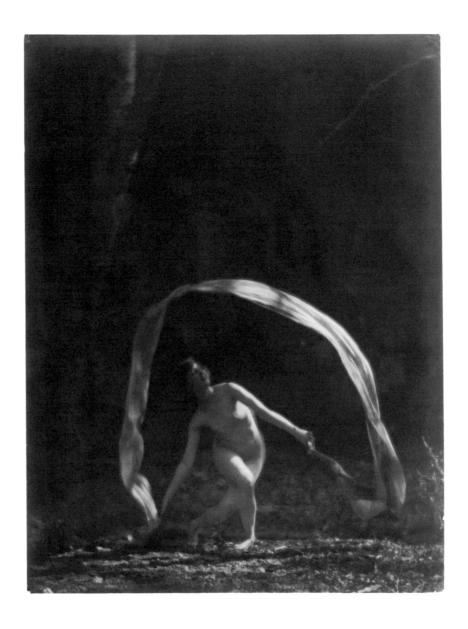

19
Arthur F. Kales
*Doris Humphrey Performing
Scarf Dance,* c. 1920
Gelatin silver print
34.4 × 27.5 cm (13$^{17}$/$_{32}$ × 10$^{13}$/$_{16}$ in.)
The J. Paul Getty Museum

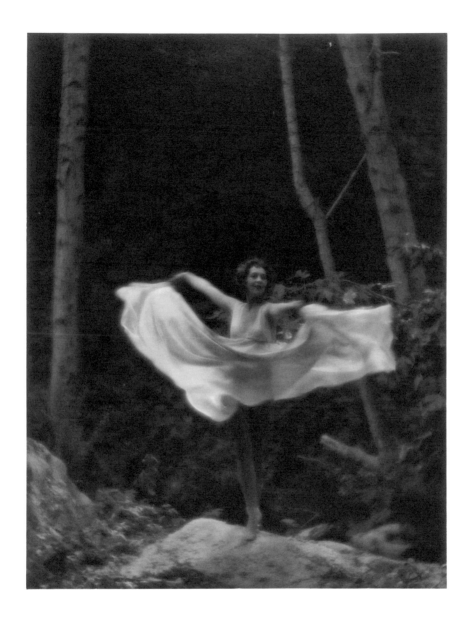

20
Arthur F. Kales
*Dancer in Landscape*, c. 1920
Gelatin silver print
34.4 × 26.8 cm (13¹⁷⁄₃₂ × 10⁹⁄₁₆ in.)
Wilson Collection

2 1
Johan Hagemeyer
*Roof—City, San Francisco,*
c. 1927
Gelatin silver print
22.9×17.5 cm (9×6⅞ in.)
Collection of Paul Sack

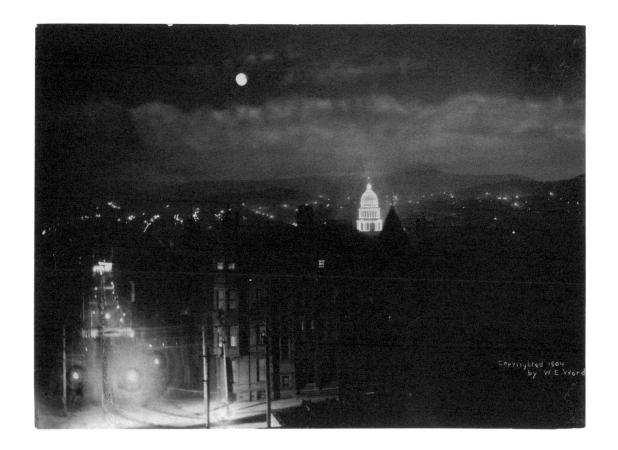

22
Willard Worden
*San Francisco at Night*, 1904
Gelatin silver print
11.9 × 16.8 cm (4¾ × 6¾ in.)
Collection of Marjorie and
Leonard Vernon

23
Leopold Hugo
*Trees on a Hill*, c. 1920
Bromoil print
32.8×25.4 cm (12¹⁵⁄₁₆×10 in.)
Wilson Collection

2 4
Leopold Hugo
*Trees*, c. 1920s
Gelatin silver bromide
34.3 × 26.3 cm (13½ × 10¹¹/₃₂ in.)
The J. Paul Getty Museum

25
Francis Bruguière
*Court Verrochio, Italian Pavilion,*
*Pan-Pacific International*
*Exposition*, 1915
Gelatin silver print, hand-colored
42.2×49.2 cm (16⅝×19⅜ in.)
Wilson Collection

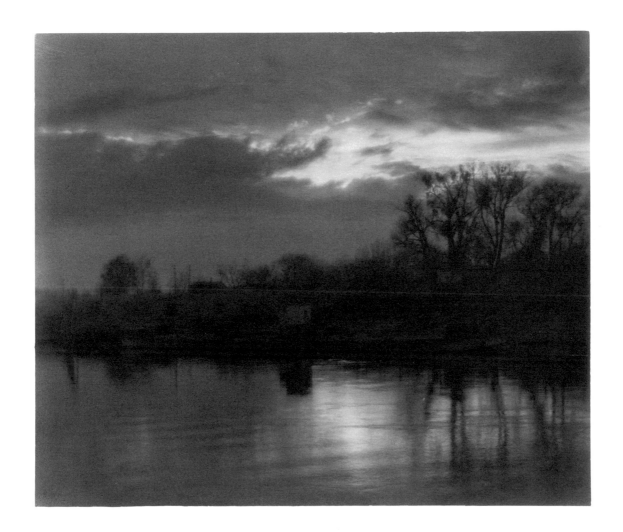

26
Ernest Pratt
*Sunset, Sacramento River*, 1917
Gelatin silver print
24.1×29.2 cm (9½×11½ in.)
Wilson Collection

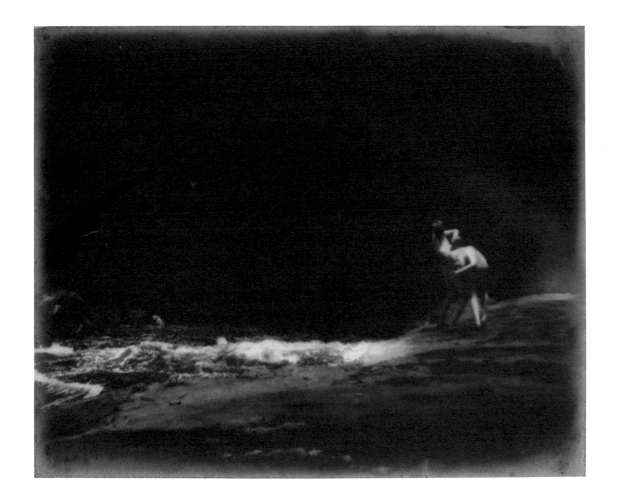

27
Louis Goetz
*Chaos*, c. 1916
Gelatin silver print
23.4 × 18.4 cm (9⁷⁄₃₂ × 7¼ in.)
Wilson Collection

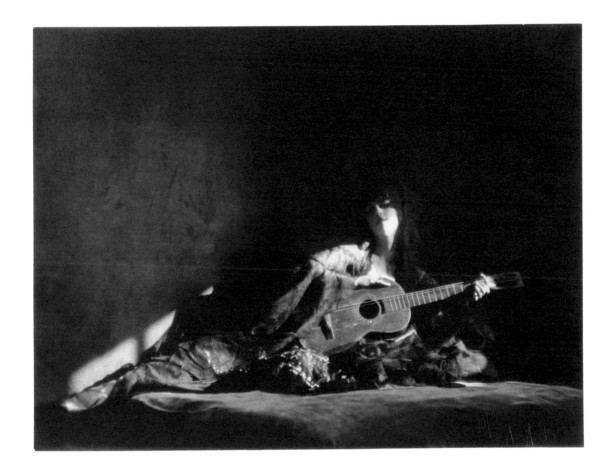

28
Helen MacGregor
*Reclining Woman
with Guitar*, c. 1921
Gelatin silver print
31.0×23.0 cm (12⁷/₃₂×9¹/₃₂ in.)
Wilson Collection

29
Imogen Cunningham
*Brett Weston*, 1923
Gelatin silver print
10.8×9.2 cm (4¼×3⅝ in.)
The J. Paul Getty Museum

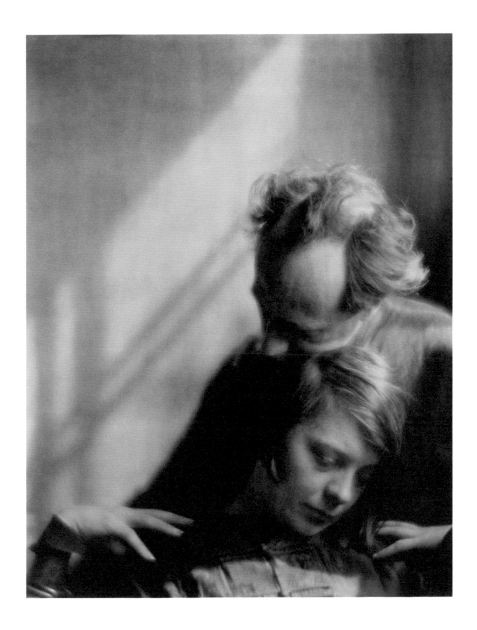

30
Imogen Cunningham
*Edward Weston and Margrethe*
*Mather*, 1922
Gelatin silver print
23.1 × 18.0 cm (9⅛ × 7⅛ in.)
Private Collection

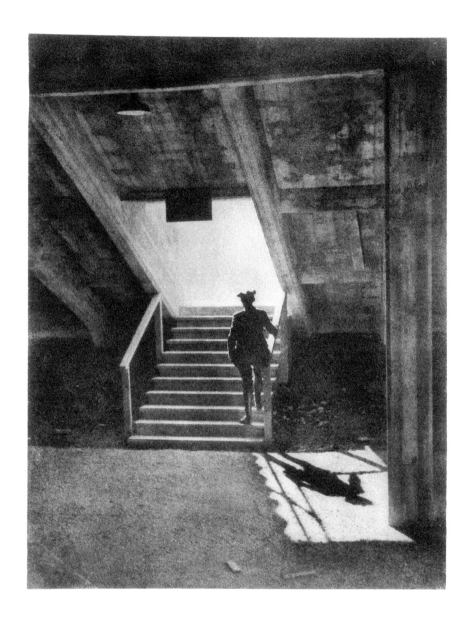

31
Henry A. Hussey
*Up to the Sunshine*, c. 1920–1925
Bromoil print
24.3 × 18.9 cm (9⁹⁄₁₆ × 7⁷⁄₁₆ in.)
San Francisco Museum
of Modern Art, gift of
Mrs. Henry A. Hussey,
in memory of her husband

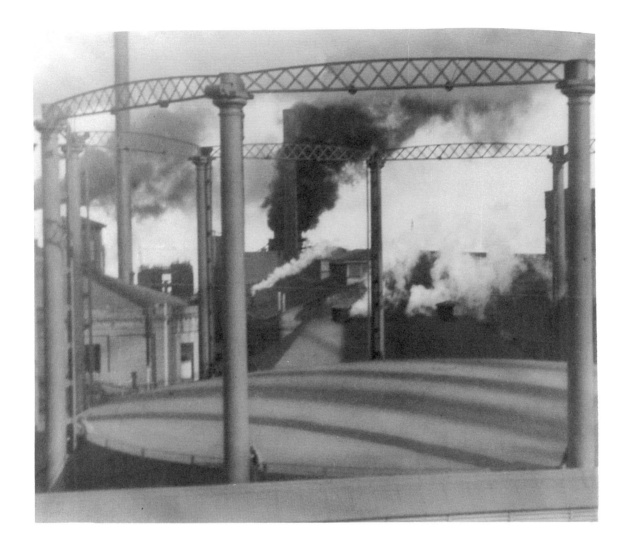

3 2
Henry A. Hussey
*The Gas Works*, 1924
Gelatin silver print
25.1×30.0 cm (9⅞×11¹³⁄₁₆ in.)
San Francisco Museum
of Modern Art, gift of
Mrs. Henry A. Hussey,
in memory of her husband

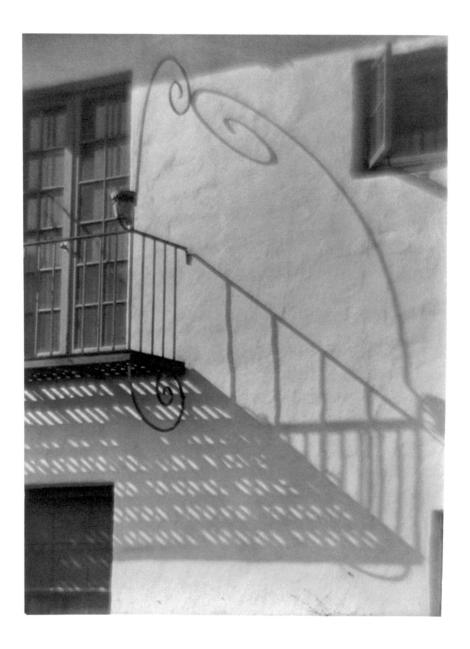

3 3
Alma Lavenson
*Iron Balcony, Biltmore Hotel,*
*Santa Barbara*, 1929
Gelatin silver print
33.0×27.9 cm (13×11 in.)
Collection of Susan Ehrens

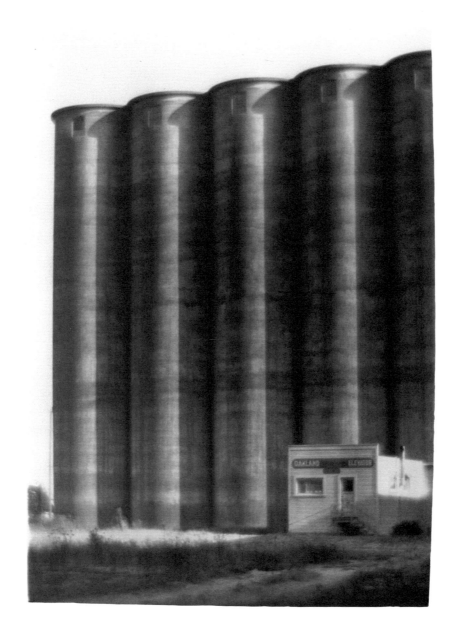

3 4

Alma Lavenson

*Grain Elevator,* 1929

Gelatin silver print

30.0 × 22.0 cm (11¾ × 8¾ in.)

Collection of Marjorie and

Leonard Vernon

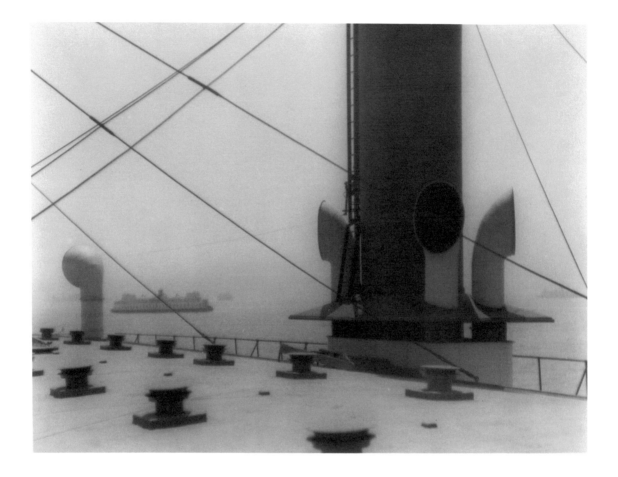

35
William E. Dassonville
*San Francisco Ferry*
*Super-Structure*, c. 1920
Gelatin silver print
42.2 × 49.2 cm (16⅝ × 19⅜ in.)
Wilson Collection

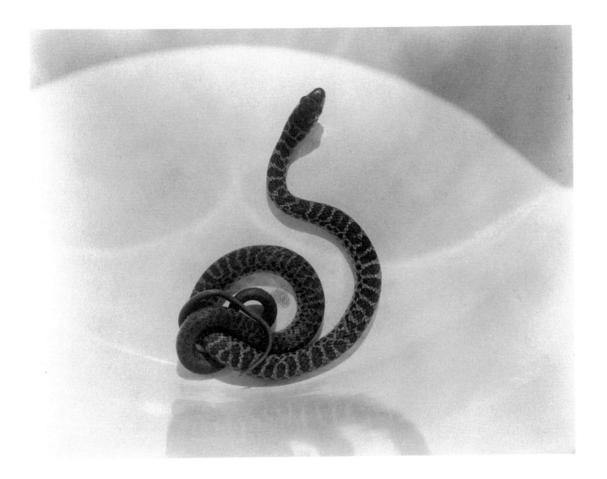

3 6
Imogen Cunningham
*Snake in Bucket*, c. 1926
Gelatin silver print
20.3×25.4 cm (8×10 in.)
Private Collection

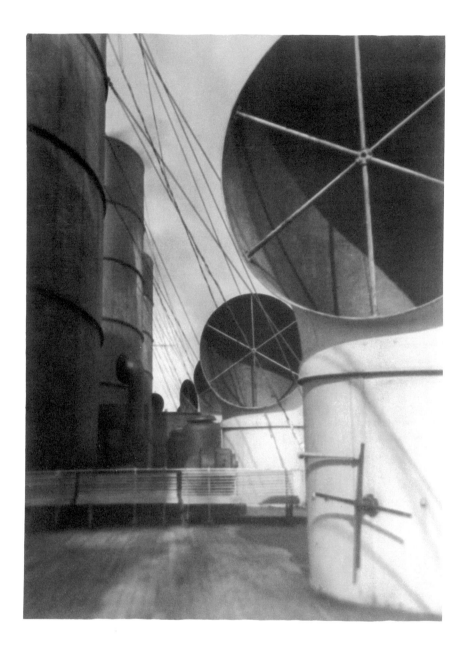

37
John Paul Edwards
*Stacks and Funnels*, c. 1923
Gelatin silver print
34.3×25.4 cm (13½×10 in.)
San Francisco Museum of
Modern Art, Purchase

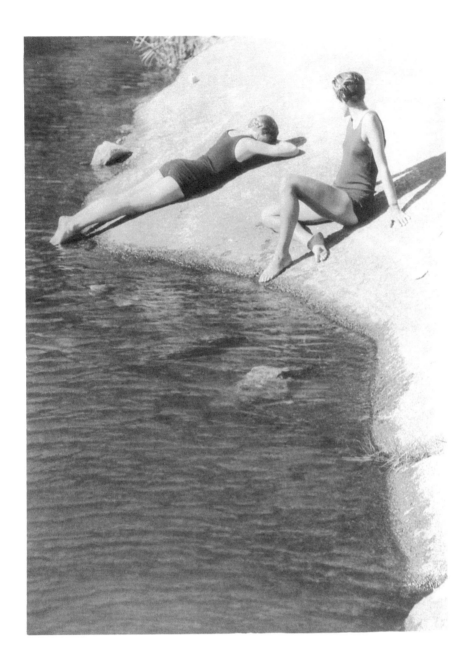

38
Ansel Adams
*Sunbathing on the Shores*
*of a Sierra Lake,* 1929
Gelatin silver print
38.1 × 27.8 cm (15 × 10¹⁵⁄₁₆ in.)
San Francisco Museum of Modern Art,
Byron Meyer Fund Purchase

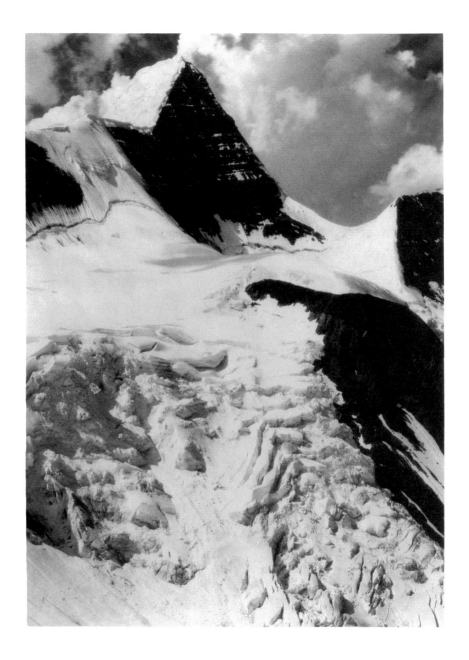

39
Ansel Adams
*Mt. Robeson from*
*Mt. Resplendent*, 1928
Gelatin silver print
27.9×35.6 cm (11×14 in.)
Private Collection

40
Ansel Adams
*Winter Scene, Yosemite (Trees in Snow
from the Ahwahnee Hotel, Yosemite
National Park, California)*, c. 1928
Gelatin silver print
37.9×27.9 cm (14¹⁵⁄₁₆×11 in.)
San Francisco Museum of Modern
Art, bequest of Albert M. Bender

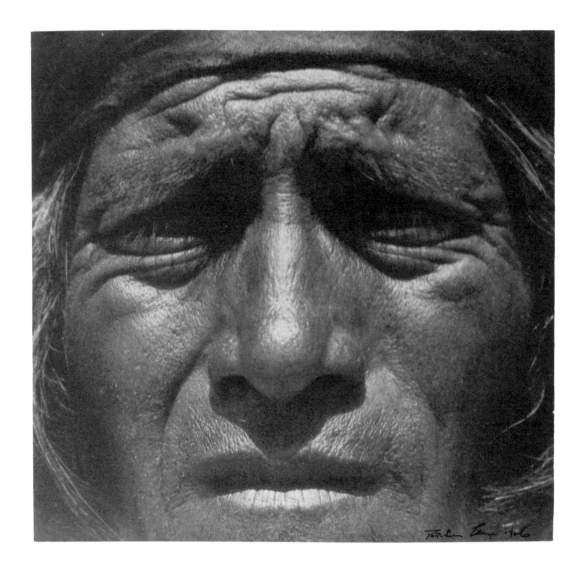

41
Dorothea Lange
*Hopi Man*, 1926
Gelatin silver print
18.4 × 19.7 cm (7¼ × 7¹¹/₁₆ in.)
The J. Paul Getty Museum

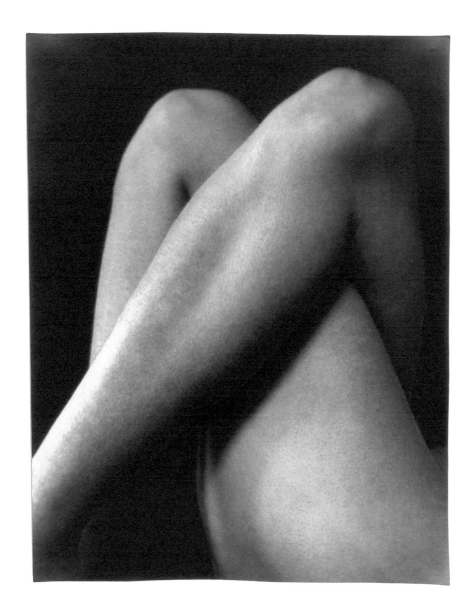

4 2
Johan Hagemeyer
*Knees*, 1930
Gelatin silver print
17.8×22.9 cm (7×9 in.)
Collection of Page Imageworks:
Tony and Merrily Page

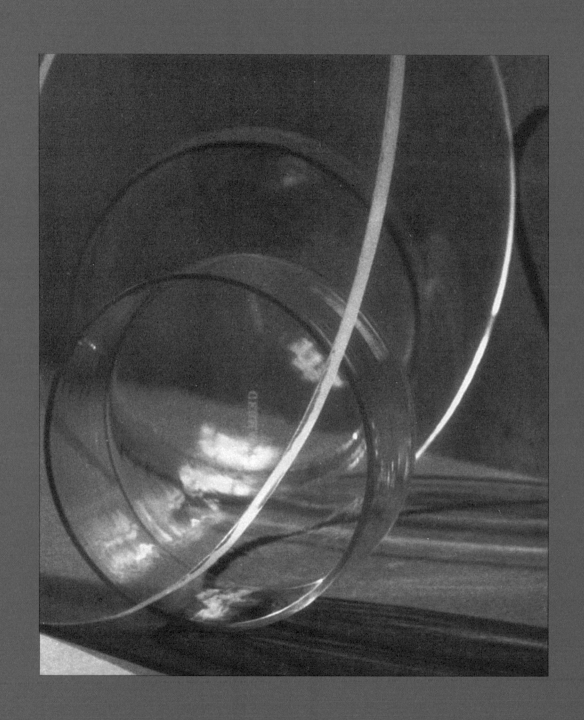

# SOUTHERN CALIFORNIA

## PICTORIALISM: ITS MODERN ASPECTS

Dennis Reed

*For almost the whole of the first quarter of the century, the Salon was the only great tool by which the insurgent photographer could exert leverage on both the public and the photographic mind, in his effort to prove that here was a medium by which an artist could speak.*

Will Connell, 1950[1]

The First American Photographic Salon was held in New York in 1904. It was a controversial event, hailed by some as a grand achievement and vilified by others as a misguided folly. Certainly, the exhibition had been organized with great sincerity and laudable intentions—chief among which was the desire to show examples of Pictorial photography from across the nation. Since most American salons of the time were strictly local events, it was an ambitious undertaking.

The legendary Alfred Stieglitz, then the most prominent champion of Pictorial photography, argued strenuously against the salon. His objection stemmed from the fact that it was to be juried by painters. However, there were others in opposition to Stieglitz who promoted the exhibition, not only because it was the first truly national salon but precisely because the selections would be made not by a single individual but by a jury. Stieglitz and his group, the Photo-Secession, boycotted the salon in protest.

Few today would question Stieglitz's contributions to photography and to modern art, but at the turn of the century some found his approach autocratic and elitist. The animosity expressed toward him because he refused to support the American Salon was so great that some writers referred to him as "Pope Stieglitz the First" and "Caesar."[2]

Controversial though it was, the First American Salon was immensely popular among Pictorialists, judging by the more than nine thousand prints that were submitted by hopeful photographers.[3] The salon was a model for future exhibitions of this kind,[4] and eventually national and international salons were presented in nearly every major city. These salons offered Pictorialists, some of whom lived in remote areas, the opportunity to have their efforts seen and valued.

The photographs of Stieglitz and the Photo-Secession, as seen in the group's famous publication *Camera Work* and at a landmark exhibition at the Albright Art Gallery in 1910, represent Pictorialism at its aesthetic peak. The Photo-Secession essentially disbanded shortly thereafter, however, and Stieglitz disowned Pictorialism in favor of modern art and "straight"

photography. But in the years that followed, many photographers, even some former members of the Photo-Secession, continued the tradition of Pictorialism that they had come to know and treasure. In 1916, for example, Clarence White helped found the Pictorial Photographers of America, the branch of Pictorialism with which most later Pictorialists identified. The movement progressed, particularly through the 1920s and 1930s, and the number of Pictorialists increased yearly. They organized camera clubs and submitted work to a seemingly endless number of salons. Pictorialism became a populist movement that found strength in numbers; there were quite literally thousands of photographers who worked in the style.

The First American Salon of 1904 was jointly organized by two clubs, one of which was the Salon Club of America.[5] As president of the Salon Club, Louis Fleckenstein had played a key role in developing this significant photographic event. In spite of his prominent position, however, Fleckenstein moved to culturally remote Southern California in 1907, the first photographer of national reputation to settle in the area.

He was attracted, like so many others, to its climate and scenic beauty, particularly to the nearby sea and mountains, and frequently photographed his wife and daughter at the beach. He soon opened a portrait studio, which prompted a contributor to *Photo-Era* to write, "The many friends and admirers of this eminent pictorialist will be glad to know that he is enjoying a high degree of success and prosperity in his new home, Los Angeles. . . . We are sure that all wish Mr. Fleckenstein continued health and success."[6] Actually, he earned a barely adequate living from portraiture and in 1923, when in his mid-fifties, he retired from the business. From the time he was first given a camera (in about 1895) until his death in 1942, he was devoted to photography as art. Fleckenstein wrote of his beginnings, "It was 38 years ago that I came into possession of my first camera—a birthday present from my indulgent wife. The enterprising salesman who sold it to her, also persuaded her that a developing outfit went with it; and so I had a good start."[7]

In this same recollection he describes the early materials he used and the first recognition he received as a photographer:

> My first prints were on solio paper, that being the simplest and most readily obtainable. When I grew tired of their shiny and wishywashy tones, I tried Aristo Platina and noted a great improvement, with their soft velvety blacks which held me for a time. Then I took up Kallitype, a home-made paper. I purchased a stock of paper at a local job printing shop; the chemicals for sensitizing the paper at a drug store, and made Kallitype prints that compared favorably with platinums. I entered one of these Kallitype prints in the Bausch and Lomb quarter century photographic competition in 1903 expecting to receive one of their illustrated catalogues of the prize-winning pictures promised all entrants. I received the catalogue all right, and I also received a cash prize of $150.[8]

The prize was large, and it placed Fleckenstein in the national limelight for the first time. By 1923 he had amassed over three hundred awards.

Not long after his arrival in Southern California, Fleckenstein became instrumental in the development of several local camera clubs. Such clubs were a mainstay of Pictorialism and were started all over California around the turn of the century. Early camera societies were primarily social clubs whose members were seeking respectable entertainment: they were as interested in social diversion as they were in photography. The Los Angeles Camera Club reported in 1901 a "booming" membership, with Saturday afternoon teas attended by both "the girls" and "the members of the sterner sex."[9]

Several camera clubs in Southern California had false starts and rocky histories. The Los Angeles Camera Club was no exception. It had been founded in December of 1899, then disappeared after 1904. A new club was started under the same name, with the motto "Better Pictures," and Louis Fleckenstein served as its first treasurer. In 1911 an article in *Photo-Era* reported, "The troubles of the Los Angeles Camera Club . . . seem to be over."[10] The writer went on to describe the events that had resulted in a marked increase in membership: "A series of three spectacular public events in quick succession proved to be the stimulant. These were, first, the Santa Monica automobile road races; next, Aviation Week, and finally the annual Pasadena Tournament of Roses. The last event took place on New Year's Day and the others within a month."[11] Such events provided both ready-made subjects and an exciting social outing, an irresistible combination for prospective club members.

By 1915, for reasons unknown, the Los Angeles Camera Club dissolved, but at about the same time the Southern California Camera Club was formed. *Photo-Era* reported that "this organization has fine quarters on the fourth floor in the Lyceum Theatre building; also a large studio with skylight, exhibition—and reading—room, darkrooms, etc."[12] Lectures and demonstrations were given by visiting Pictorialists such as Laura Adams Armer and John Paul Edwards.

"The club," the writer in *Photo-Era* continued, "has recently finished a very successful first annual exhibition, which included among many worthy pictures several . . . by E. H. Weston, that have received various official honors elsewhere."[13] Such exhibitions provided a place for members to share their efforts, and a major salon offered an opportunity to see new ideas and techniques. The Southern California Camera Club's annual members' exhibition became, in 1922, the "Southwest Salon" and was shown at the Southwest Museum, with which the club was affiliated. Eventually, in 1928, the club changed its name to the Los Angeles Camera Club, the third group to take this name, and the annual salon was retitled the All-American Salon, because works from across the nation were shown.

The camera club that was to have the most significant effect on the history of photography in the region was the Camera Pictorialists of Los Angeles. A founding club member, Fred Archer, reflected thus on its beginnings:

> *From the controversies that, for a period of years, involved the various groups of camera workers throughout the country and which produced the 'Linked Rings,' 'Photo-secessions,' 'Salon Clubs,' 'Federations,' and traveling portfolios, was finally born the salon, that agency of artistic propaganda whose criterion of usefulness has been justified by its vitality. A score of these heroic precursors . . . have established photography as an authentic and esthetic means of self-expression. This they have achieved . . . by a bond of conception and a breaking of precedent native only to free and vigorous art. This common heritage of revolt is also the story of the Camera Pictorialists of Los Angeles.[14]*

The idea for the new club originated with Margrethe Mather. She was a free spirit, with contacts in various intellectual and cultural communities, and she was a fine photographer. She was also the studio assistant to Edward Weston, who was at the time working in the Pictorialist style. Mather convinced Weston and two other Pictorialists to join her at Fleckenstein's studio, where they formed the new club. The group added six other charter members but kept a loose framework with little formality. They gathered somewhat casually before meetings at a Quaker cafeteria, and there were no by-laws and no dues. Membership was limited to fifteen, and the only requirement was the presentation of a new print at each month's meeting. Fleckenstein was

elected director, but for whatever reason, Mather and Weston dropped out before the group organized officially in February of 1914.[15]

The club's overriding ambition was to establish an important salon, and in 1916 an exhibition was held under its auspices at the Los Angeles Museum of History, Science and Art. The club ultimately disassociated itself from the project because the exhibition became invitational rather than juried. It is also claimed that Weston hung his work separately in the Arts and Crafts section and stole the show.[16]

Finally, in 1918, the club organized its first international salon. Fleckenstein reported with great pride in *Photo-Era* that the salon "was so successful that it will undoubtedly become an annual event. The attendance for the month was estimated at over sixty thousand . . . and on Sunday afternoons the place was packed with humanity."[17] It must be said that many of those attending were general visitors to the museum and were probably unaware that a photography exhibition awaited them. Nevertheless, people in huge numbers saw the club's efforts and the salon did continue to function at least through 1950, becoming one of the longest running and most respected exhibitions of Pictorial photography.[18] Fleckenstein continued his description of the 1918 salon, "For the first time in the history of the museum, the entire main gallery was given over to the photographs. The gallery is well lighted and commodious and is said to be one of the finest in the country. . . . In all, 171 pictures were hung, contributed by 58 exhibitors, and of these there were 33 gum-prints, 12 carbons, 16 platinums, 2 oil-prints, and the others on developing or bromide papers."[19]

Pictorialists were less interested in straightforward photographic realism than in using manipulative techniques to produce expressive effects. In an effort to create prints that were more personal and less mechanical, many Pictorialists drew onto prints by hand or used unusual printing techniques, such as gum or oil, that produced somewhat different effects with each printing. Prints resulting from such exotic processes were clearly neither the efforts of the hobbyist nor could they be confused with the casual snapshot.

Special processes often produced images that lacked detail. Soft-focus lenses further decreased the insistent realism of the camera and were helpful in suggesting mood and atmosphere, both qualities prized by Pictorialists. Fleckenstein, like most Los Angeles club members, generally produced a restrained version of Pictorialism without the use of extensive manipulations or elaborate techniques. His approach was essentially the same as it was later in 1929, when he advised would-be Pictorialists:

> *Bear in mind, however, that until you have a fairly successful picture in your negative to begin with, you are doomed to disappointment if you think you can bungle through to success by a juggling process of working up the negative then messing up a lot of good paper with bad pigment printing and brush-work. Pictorial photographs do not happen that way. Many good pictures may be ruined by misapplied zeal in after-manipulation. Personally, I have always taken the easiest way by letting the camera do the work, and then printing what is in the negative. Sometimes a little retouching, or rubbing down a highlight where it is not wanted, will improve it; but that is about all.*[20]

The young woman in Fleckenstein's *The Girl from Delhi* [Cat. 49], for example, is modeled with beautiful simplicity against a plain background. She is seen in profile, her head gracefully turned so that her neck and shoulder form a gentle "S," a typical Pictorial structure with roots in nineteenth-century photography.

Paramount to the Pictorialist was the spiritual or emotional content of a picture. One of

Fleckenstein's dance photographs [Fig. 1] was commended for both these qualities in *Photograms of the Year*, an important English annual. The reviewer wrote, "Truly emotional pictures of dancing are not numerous. . . . The wonderfully portrayed figure in *Rose Dance of the South*, by Louis Fleckenstein, may emotionally be taken as that of one invoking the god, the sun."[21] The reviewer goes on to discuss ancient sun worship and mythology and by such comparisons, to the Pictorialists' way of thinking, promoted the notion that art photography could contain serious and commendable ideas. It must be remembered that at this time the "Kodak" was common and anyone could trip a shutter and make a photograph. Pictorialists reasoned that if their work was to be seen as art they had to demonstrate that their photographs were different from ordinary snapshots—that Pictorial photographs were art by virtue of their skillful presentation of beautiful subjects and noble themes.

> *California has developed independently a group of pictorialists whose work has won recognition at all of the important Salons, in this country and abroad, and their growth has been remarkable when one considers their isolation.* Arthur F. Kales[22]

•  •  •

One of the most distinctive characteristics of Los Angeles Pictorialism was a tradition that might be described as that of the dramatic narrative. Narrative themes were a standard element of Pictorialism; that is, the image often seemed to tell a story and was given a literary or poetic title, and at times took the form of allegory. This tradition was given new life in Los Angeles by the local film industry: here, narrative images took on a decidedly dramatic, staged look.

Arthur F. Kales, a member of the Camera Pictorialists of Los Angeles, worked in this manner. His subjects were often theatrical and evocative, suggesting fanciful tales. Kales's photographs appear to depict stories of ancient or imagined themes and legends, evident in such titles as *In the Temple of the Sun, When I Was a Queen in Babylon,* and *Lady of the Tower. Crime* [Cat. 63], an eerie image of mystery and evil, is a fine example of this dramatic tradition.

Kales frequently used dancers or actresses as models, often posing them on film sets or with props, which added to the theatrical appearance of his work. D. W. Griffith's set for *Intolerance* was one of the more celebrated film locations used by Kales [Fig. 2]. He is said to have been welcome on any film set in town, and certainly the opportunity to use actresses as models must have been irresistible, since he photographed many stars, including Gloria Swanson [Cat. 59]. Kales photographed only as an amateur, however, and never for commercial gain. To do so, as he saw it, would have violated the respectability of his effort.

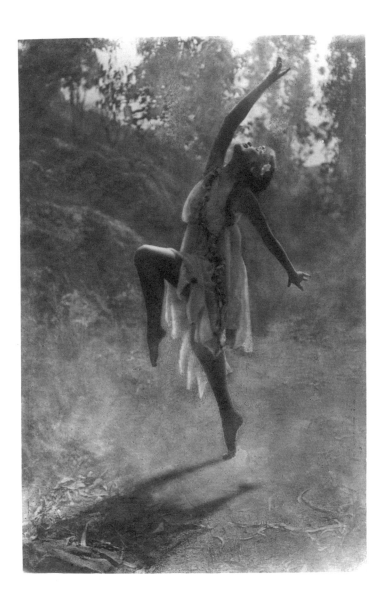

FIGURE 1

Louis Fleckenstein

*Rose Dance of the South,* c. 1916

Bromide print

23.1 × 15.5 cm (9³⁄₃₂ × 6³⁄₃₂ in.)

Reed Collection

Kales moved to Los Angeles from San Francisco in 1917 and joined the Camera Pictorialists club the following year. By 1922 he had begun using the complicated technique of bromoil transfer, of which he became the acknowledged master. The procedure involved the making of a regular bromide print, which was then bleached and hardened. This became a printing matrix that was then hand-inked, and a transfer was made by pressing a sheet of paper against the inked matrix. Thus the finished print is not actually a photograph as such, but an ink impression. In the hands of those less talented than Kales, this process resulted in fuzzy, indistinct prints of indifferent quality as photographs.

Kales deplored photographers who used difficult techniques carelessly or for the purpose of camouflaging poorly conceived images. He offered clear advice to those who would attempt the demanding technique of bromoil transfer:

> *If a print is properly inked one pull, one impression should make a perfect transfer. The advice to re-ink and make multiple impressions to build up the image is bunk. . . . In fact when more than one pull is needed one must confess there has been a lack of perfect handling of the first inking. All control and all the art should be in the original bromoil. Everything else is doctoring.*[23]

Few photographers could maintain the detail that is seen in *Cameo* [Cat. 60], a depiction of two Morgan Dancers transformed into a statuary frieze.[24]

The dramatic tradition of which Kales was a part can be seen in the work of others, of

course. Louis Fleckenstein produced at least one such image, an enigmatic portrait of Kales himself [Cat. 61]. William Mortensen, a student of Kales, also worked in this dramatic tradition. He made his reputation photographing Hollywood stars and producing stills for various films, including Cecil B. DeMille's *The King of Kings*. Like his mentor, Mortensen was a superb technician. He wrote nine books explaining his complex techniques, which he called the "Mortensen System." Yet, ironically, in his magnum opus *Monsters and Madonnas* he decries reliance on technique as one of the monsters from which the Madonna of creativity must be safeguarded.

Mortensen's work was always staged, using models, costumes, and props to create *tableaux vivants*. His expressions, often bizarre and inflated, never lacked impact. His account of how he came to create *Human Relations* [Cat. 65], which was published in *Monsters and Madonnas*, describes how a simple telephone overcharge led him to produce this powerful image:

> My hatred stirred around in my mind and got itself involved with several other pet hates
> that were disturbing me at that time. These were days when stocks were stopping divi-
> dends, when lives of thrift and industry were being wiped out by the foreclosing of mort-
> gages and the closing of banks. . . . Everywhere there was evident a spirit of 'Take what
> you can, and to hell with your neighbor.' Those who were strong seemed to be, in sheer
> wantoness, gouging the eyes of humanity.[25]

In many of Mortensen's photographs, including his Christ-like *Self-Portrait* [Cat. 66], there is a surreal quality. His work shares with the Surrealists an obsession with sexual innuendo, a love of the unexpected or grotesque, a use of psychological drama, and a sense of a world not real but dreamed. *Death of Hypatia* [Cat. 64], for example, is a haunting, sexually charged image in which Hypatia, cast as a female of half flesh, half stone, is being dragged to her death by a looming monk. In its depiction of the figures, it owes a debt to Arthur Kales.

Hollywood attracted many photographers who came looking for employment in the studios, and their art photographs often had little to do with the dramatic narrative of cinematic photography. Karl Struss, for example, a former member of the Photo-Secession whose work had been reproduced in *Camera Work*, arrived in Hollywood in 1919. He brought a Pictorialist's sensibility and technique to filmmaking, and in 1929 he shared the first Academy Award in cinematography for the motion picture *Sunrise*. Because of his early achievements, Struss was greatly respected among local Pictorialists and served as a juror for a number of area salons. Although filmmaking occupied most of his time, he occasionally photographed Southern California, as in *Storm Clouds* [Cat. 44], a moody landscape seen in silhouette, and *Sails* [Cat. 70], a more modern composition of jutting angles. Both prints were reproduced in *Pictorial Photography in America*, the most prestigious publication of Pictorialism during the 1920s.

Most Pictorialists, however, came to Hollywood looking for work as still photographers. James N. Doolittle, for example, was a noted Pictorialist who worked first in San Francisco and then in Los Angeles, where he was a member of the Camera Pictorialists club. During the 1930s he was sought after as a photographer of the Hollywood stars because he was capable of producing color prints. His camera was custom-made to produce three plates, one for each subtractive color—magenta, cyan, and yellow—which were then overlapped to form a finished tricolor carbro print. The exposure was generally seven seconds, long enough to expose each of the three plates but sufficiently brief for most stars to hold the pose: Loretta Young is said to have been especially good at this [Fig. 3]. Doolittle's career ended after Kodachrome came on the market in the late 1930s. Since the new film required no special equipment, any photographer could then produce color prints.

Hollywood was not the only magnet that drew Pictorialist photographers to California. As the attractions of the state, with its picturesque arroyos and abundant flowers, became more widely known in the 1890s, landscape painters from the East Coast and Europe began arriving. Some served as jurors for early Los Angeles area photographic salons, just as painters had served on the jury of the 1904 First American Salon in New York.

Pictorialists found the California landscape a convenient, often picturesque, and highly varied subject. Their resulting photographs were remarkably different. Otis Williams traveled north to picture California as an idyllic vision in *Utopia, Northeast of Cypress Point* [Cat. 43]. Beauty was discovered in the new forms of local industry, as in *Shovel* [Cat. 77] by Fletcher O. Gould. The pleasures of the sea, a favored theme, is apparent in prints by three Camera Pictorialists, Ernest M. Pratt [Cat. 48], Oscar Maurer [Cat. 47], and Julius Cindrich [Cat. 71].

Kirby Kean, one of the youngest Camera Pictorialist members, produced a portrait of Southern California in 1937 that summarizes the Southland with elegant simplicity [Cat. 78]. Only the essential elements are represented: the ubiquitous automobile, imported resources symbolized by the electrical tower, and the indigenous Joshua tree. Humanity is quite literally edging nature out of the picture. It is a depiction of Southern California that Fleckenstein might not have recognized in 1907.

•         •         •

Artists and photographers were not the only ones beckoned by Los Angeles. Industry was booming after the turn of the century and people came for jobs. Oil was discovered and the petroleum industry grew [Fig. 4]; water was imported from the north and agriculture expanded. The two rivaled each other as major employers and later, in the 1930s, aviation became a leading industry in the area. Meanwhile, retail and service businesses thrived to meet the needs of the growing populace and the visiting tourists. All this commercial activity created a market for advertising photography, and many Pictorialists willingly applied their skills to this growing field. Some of these images stand as notable aesthetic accomplishments. Doolittle's untitled perfume adver-

FIGURE 3

James N. Doolittle

*Loretta Young*, c. 1930

Tri-color carbo

33.0×25.4 cm (13×10 in.)

Collection of Michael Dawson

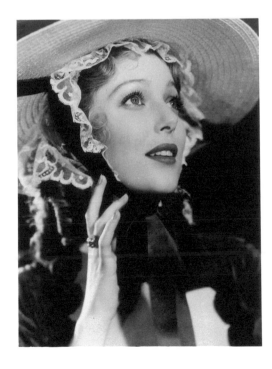

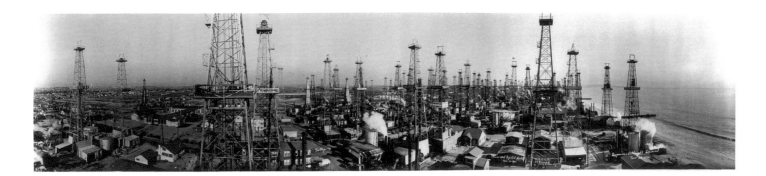

tisement [Cat. 67] is an excellent example of an image inspired by Art Deco, a prevalent style in advertising in the 1920s and 1930s.

The new, bustling world of industry—the shapes of its machines, the forms of its architecture, and the odd angles of view seen from aircraft—provided artists and photographers with subjects and shapes that were very different from the pastoral scenes associated with turn-of-the-century Pictorialism. Many photographers, including members of Pictorialist clubs, responded to these new influences. Such modern trends were widely seen in Pictorialist salons and publications of the late 1920s and 1930s. A writer for the 1929 issue of *Pictorial Photography in America* observed:

> In looking over the pages of this annual it will be seen that, more and more, the American photographers are being touched by so called Modernism; by a new-found interest in our stark and skyscraper civilization. More and more they are yielding to the beauty of cubes; to sharply opposed effects of shadow and light; to the Picasso-like quality which we everywhere see reflected in the life about us.
>
> And the inevitable result of this encroachment of modernism has been that the old-time quality of "sentimentality" is very much on the decline in our photographic art. The once popular "story-telling" pictures, the tender landscapes with sheep, the bowls of flowers, the portraits of little children, have had to make way for prints in which a new . . . spirit is evident.[26]

Many Pictorialists, especially in Los Angeles, produced images that seem today more modernist than Pictorial, yet they still called themselves Pictorialists. The Pictorial movement was, in fact, a highly diverse and complex phenomenon. Some Southern California photographers were Pictorialists in every sense of the word, while others blended Pictorial and modernist ideas. Still others who had once been Pictorialists later abandoned Pictorialism completely.

This was the case with Edward Weston, who came to Los Angeles in 1906 as a young man of twenty. An article in *The American Magazine* described his first studio, established in 1911:

> Out in the town of Tropico (now Glendale), a beautiful suburb of Los Angeles, stands a shack studio of rough boarding that is so full of art that its range of influence reaches to the ends of the earth.
>
> In that studio . . . dreams and works Edward H. Weston, "photographer," as the simple mission-style, brown-stained sign hanging in front of the door announces. . . .
>
> Last June, to the great London Salon of Photography, held in the galleries of the Royal Society of Painters in Water Colors, in London, Weston sent his six best-loved pictures. Of these, five were deemed worthy by the judges of hanging beside those of the most noted photographic artists in the world.[27]

FIGURE 4

C. C. Pierce and Company
*Venice-Del Rey Oil Field*,
November 25, 1930
Gelatin print
26.0 × 107.9 cm (10¼ × 42½ in.)
Stephen White Collection (II)

The article continues, quoting Weston:

*Many of my neighbors do not believe that I am making pictures like these . . . or that I am really exhibiting them at the salons. They think it is some kind of hoax, because, they say, how can a photographer doing this work in a little shack like mine win the great awards? He ought to be in a large city with a splendid studio. We don't believe he makes these pictures at all.*[28]

Weston's early works were widely admired as compositions of high sensitivity and imagination, and his images and themes displayed soft-focus interpretations of mood. At this stage in his career his photography was strongly rooted in Pictorialism, and it was as a Pictorialist that he was first internationally exhibited.

But in 1914 a poem entitled "The Gummist" appeared in *Photo-Era* magazine. The poem was written by Weston and satirized Pictorialist photographers who made "fuzzy" prints by using the gum-bichromate process. Its publication signaled the beginning of Weston's gradual and sometimes ambivalent transition from Pictorialist to "straight" photographer. This transformation was undoubtedly fueled by Weston's visit to the 1915 Panama-Pacific International Exposition in San Francisco, where, apparently for the first time, he saw avant-garde art.[29] Although his work remained essentially Pictorial throughout the remainder of the decade, these new influences on Weston's art can be seen in images like *Bathing Pool* [Cat. 54]. Such works blended Pictorialist focus and tone with modernist spatial construction, where angles and geometric shapes have replaced the gentle "S" curve typical of Pictorialist form.

FIGURE 5
Edward Weston
*Epilogue*, 1919
Platinum print
24.5 × 18.7 cm (24½ × 18⅜ in.)
Collection of Center for Creative
Photography, Tucson, Arizona
© 1981 Center for
Creative Photography,
Arizona Board of Regents

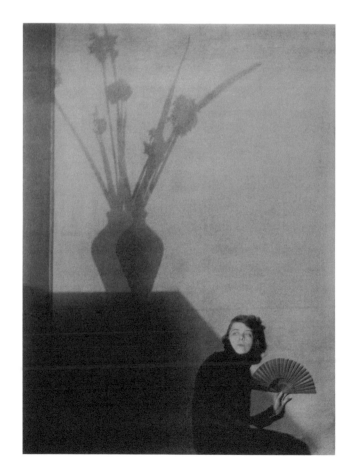

Further indications of Weston's avant-garde leanings can be seen in those works that employed "cubistic" angles and that were sometimes infused with elements of *Japonisme*. (It is worth recalling that the earliest European modernist painters and sculptors had been influenced by Japanese art also.) Such images as Weston's *Epilogue* [Fig. 5] were quite revolutionary, and their significance was misjudged by some critics who saw them as violations of proper Pictorial subject and style. *Photograms of the Year 1921*, for example, included two photographs, one by Margrethe Mather and one by Weston, both done in this new modernist style. The critic reviewing them was so perplexed and outraged by these photographs that he suggested they were made out of "pure cussedness."[30]

It is interesting to compare Weston's last great Pictorialist image, the 1920 portrait of Margrethe Mather entitled *Prologue to a Sad Spring* [Cat. 50], with a more modernist portrait done the same year, that of Betty Brandner in her attic [Cat. 58]. In both photographs the images are dominated by shapes seen on a flat surface. In *Prologue*, dreamlike shapes are cast by the natural form of the tree; in the Brandner portrait, by contrast, the shapes are angular, ambiguous, and not derived from nature—distinctions that make such transitional works more modernist than Pictorial.

It is impossible to gauge with certainty the degree of influence Weston's changing ideas had on the course of Southern California photography. His close associates not only reflected his vision but would also influence it. Mather's portrait of him play-acting at the top of a stairwell [Cat. 57] is an image inspired by the "cubist" influences to be found in Weston's famous attic pictures. Conversely, Weston's interest in *Japonisme* was no doubt encouraged by Mather, who had business dealings with the Japanese in Los Angeles and a strong feeling for their art.

Many of those outside Weston's immediate circle were admirers of his photography: Arthur Kales, for example, owned a copy of *Epilogue*. More to the point, many photographers produced works similar to those by Weston, such as E. M. Pratt's untitled print of two women by the side of a pool [Cat. 53], an image that roughly parallels Weston's *Bathing Pool* [Cat. 54].

FIGURE 6
Edward Weston
*Pelican's Wing,* 1931 [possibly included in Group f/64 exhibition as checklist #38]
Silver print
19.1×24.1 cm (7½×9½ in.)
The Henry E. Huntington Library and Art Gallery
© 1981 Center for Creative Photography, Arizona Board of Regents

FIGURE 7
Edward P. McMurtry
*On the Elbe,* c. 1930
Gelatin silver print
20.3 × 25.4 cm (8 × 10 in.)
Reed Collection

Perhaps Weston's greatest impact on Southern California Pictorialists came in the 1930s, while he was living in Northern California. He had long since disowned Pictorialism and was producing the straightforward, unmanipulated prints of sea shells and sand dunes for which he is well known today. Such works were the foundation for a new movement toward "pure" photography, which was introduced in 1932 with an exhibition in San Francisco's M. H. de Young Museum by Group f/64, an organization newly founded by Weston, Ansel Adams, and several other Northern California photographers[31] (see page 18). Group f/64 rallied against Pictorialism as a purveyor of cheap tricks and false values, decrying what they considered to be its reliance on print manipulations, soft focus, and "imitations" of other arts such as drawing and painting. Ironically, most of the members of Group f/64 had themselves been ardent Pictorialists at one time.

Group f/64 photographs are typically sharp in focus, with objects seen close up, emphasizing their textural qualities, as can be seen in Edward Weston's *Pelican's Wings*, which juxtaposes feathers and stone [Fig. 6]. These photographs were meant to represent the truth of what the photographer saw and felt at the moment the film was exposed; they were not meant to be the artful creation of darkroom manipulations. Group f/64 emphasized previsualizing an image and printing it full frame without cropping. This was in contrast to the practice of most Pictorialists, who tended to photograph a broad scene and then to enlarge the section of interest, as is the case with Edward P. McMurtry's *On the Elbe* [Cat. 69 and Fig. 7].

One of the watershed confrontations of Pictorialism and modernism occurred when William Mortensen engaged Ansel Adams in what amounted to a debate in the pages of *Camera Craft* magazine. In a series of articles published during the mid-1930s, Mortensen defended the merits of Pictorialism while Adams extolled the superiority of "straight" photography. Adams declared that his approach had

> nothing in common with 'Pictorial' aims and means, and I consider all phases of manipulation of negatives and prints, all diffused-focus, retouched, etched, colored, multitoned or pigmented images entirely beyond the strict limitations of the photographic medium. Photography, as a pure medium of art, does not admit conceptions that are reminiscent of other mediums—painting, lithography, aquatone, etc.[32]

Mortensen found the Group f/64 approach "sterile and unfertile." He felt passionately that reality is

*something to be dealt with creatively, respecting it as the sculptor respects the tough marble under his chisel, but not permitting it to dictate the bargain. The 'thing-in-itself' is of no account save as a vehicle of expression. Hence the forms, the lines, the details are all subject to significant simplification and alteration in order that the picture-idea may more clearly express itself.*[33]

From today's perspective, the objectives of Group f/64 can seem clear but narrow. After all, Pictorialism offers its own rewards. While Pictorialism may lack the clarity and detail of "straight" photography, it provides suggestion, poetry, and drama. More importantly, few photographers worked exclusively in either a Pictorialist or a purist mode. Many Pictorialists adopted ideas and sampled techniques as they saw fit, abandoning notions that failed to hold their interest and employing those that intrigued them. Some used exotic techniques, but many did not. Images were created by Pictorialist club members that were virtually identical to those shown at the Group f/64 exhibitions. Such is Fletcher O. Gould's untitled photograph of a figure and smokestack [Cat. 79], a relatively sharp-focus industrial shot that resembles several in the Group f/64 show.

The ideas of Group f/64, with an insistence on previsualization, sharp focus, and glossy printing papers, had a tremendous effect on Pictorialists by promoting an interest in "straight" photography. By the late 1930s and throughout the 1940s most photographers were employing sharp focus and unmanipulated printing techniques, with the result that eventually many of the photographs shown in Pictorial salons were unidentifiable as Pictorialist.

In Los Angeles the requirements of commercial work further encouraged the transition to "straight" photography. In the early years most photographers were amateurs, but by the 1930s many Camera Pictorialists were doing commercial assignments for advertisers, whose demands were for clear images. Some of these commercial works were even included in area salons. For example, Herman V. Wall, who was a Camera Pictorialist member, exhibited an illustration done for Vultee Aircraft in the 1942 Los Angeles International Salon [Fig. 8].

FIGURE 8
Herman V. Wall
*Berlin Express: Illustration for Vultee Aircraft,* 1941
27.9 × 35.6 cm (11 × 14 in.)
Collection of Herman V. Wall

FIGURE 9
Charles Sheeler
*Power House No. 1—*
*Ford Plant*, 1927
Gelatin silver print
19.3 × 15.7 cm (7¹⁹⁄₃₂ × 6³⁄₁₆ in.)
The Lane Collection,
Photo, Courtesy,
Museum of Fine Arts, Boston

In the later years, particularly during the 1930s and 1940s, some unrelenting Pictorialists held tightly to the old ideas, creating works that seem ever more anachronistic. But a number of earlier Pictorialists responded to the forms and themes of modern life by incorporating modern subjects, shapes, and composition into their expressive vocabulary. The multiple shadows, the attitude of the figure, and the cutting angle in the upper corner of Lynton Vinette's *Self-Portrait* [Cat. 68] are all expressions more modern than Pictorial; and in *Grotesque Shadows* [Cat. 76], Roland E. Schneider contrasted the angular severity of modern architectural forms with the whimsical shapes of human shadows. In *Trapeze Act* [Cat. 83], Florence B. Kemmler photographed the performers' apparatus, with its ropes and supports, against a plain background to create a modern composition based on shape rather than the illusion of three dimensions.

Another of Kemmler's photographs, *Symbols of Progress* [Cat. 80], is a powerfully modern image both in its subject and in its stark simplicity. Her subject is nearly identical to that of the Ford plant in Detroit [Fig. 9], photographed in 1927 by Charles Sheeler, a famous painter and photographer who had no association with Pictorialism. Perhaps Kemmler saw a reproduction of Sheeler's work and, recognizing its symbolic impact, chose to use a virtually identical scene at a San Diego utility. Or perhaps they were both independently responding to the same impulse. Such a commanding structure was very inviting to a photographer, after all, and Kemmler certainly shared with her contemporaries an optimistic view of industry, seeing in such smokestacks the embodiment of a new modern age.

Some Pictorialists attempted an occasional daring modernist experiment, even if the vast majority of their works were strictly Pictorial. Such was the case with Fred Archer, one of the founding members of the Camera Pictorialists club, who produced the nearly abstract *Reflections of a Mirror* [Fig. 10]. The circumstance of its creation remains puzzling and, because no print

is known to exist, a complete understanding of its origin is obscured; but fortunately the image was reproduced in the 1932 issue of *The Pictorialist*.[34] Photographer Nicholas Haz wrote about this work some years later, when the Museum of Modern Art failed to include it in an exhibition of modernism, complaining that "it was one of the first abstract photographs made in this country and it should justly have been included in a historical show of photography."[35] Archer's image is an abstract arrangement of light reflections, done perhaps around 1920.[36] It was a courageous experiment at a time when such things were usually mocked, not emulated.[37]

Other modernist experiments were conducted by a number of Pictorial photographers in Southern California during the 1930s. Anne Brigman, the famous Photo-Secessionist who was the grande dame of San Francisco Pictorialists, moved to Los Angeles in 1929, where she created a series of abstract studies of sand erosion [Cat. 82]. And Dr. Dain Tasker, a radiologist, made fascinating pictures of flowers using X-rays. The photographer Will Connell helped perfect a method for printing the negatives, and Tasker gave the finished prints to graduating nurses.[38]

Perhaps no one represents the "modern Pictorialist" better than Will Connell. His friend Merle Armitage, a well-known impresario and writer of the period, contributed a review entitled "The Spirit of the Machine" to an area newspaper, in which he described an exhibition of Connell's work in 1930:

> In Will Connell, who calls himself "a pictorialist," we have a master guiding his obedient servant, the camera.
>
> Connell is a fine artist, which does not rob him of a splendid faculty of reporting, for Will Connell's photographs report with fine feeling, understanding and conviction, the subjects portrayed.[39]

FIGURE 10
Fred Archer
*Reflections of a Mirror,* c. 1920
no extant print
reproduced in *The Pictorialist*.
Los Angeles: Adcraft, 1932.
Plate 95.
Reed Collection

Connell became active as a Pictorialist first with the Los Angeles Camera Club and later, in 1927, with the Camera Pictorialists, having exhibited at the annual salon since 1922. He clearly considered himself a Pictorialist, yet at the same time much of his work is exceedingly modern in approach. Only his earliest works, such as *A Study in Diagonals* [Cat. 75], are in the soft-focus style typical of Pictorialist photography.

The exhibition that Armitage had reviewed was held at Jake Zeitlin's gallery and bookstore on Sixth Street. In those days, Zeitlin was the center of an important intellectual community in Los Angeles that included architect Frank Lloyd Wright, Armitage, *Times* art critic Arthur Millier, and Connell.[40] In 1980 Zeitlin recalled:

> *Whenever somebody interesting would come to town, we'd rope them in, then I would take them over to Will Connell, and Will would pose them and shoot these old-fashioned, cabinet-type photographs of them. Then we would all go to dinner to a French Restaurant on West Sixth Street . . . and then we would gather at my shop and talk and make a lot of noise and argue and generally have a hell of a good time.*[41]

The portraits he spoke of were parodies of nineteenth-century cabinet cards. An inscription at the bottom of each read "Connell—Swell Photographer."

After Connell's death, photographer Philippe Halsman wrote, "When I remember my friend, Will Connell, I think first of the man—warm, open, and big-hearted. He was intensely alive and his past as colorful as he. Before he became a photographer he was a cowboy, porter, soda jerk, cartoonist, pharmacist and photo supplier."[42]

Connell had become a respected advertising and studio photographer who made little distinction between his art photography and his commercial work; his paid assignments engaged his ingenuity and artistry just as much as his private work. *In Pictures: A Hollywood Satire* [Fig. 11], produced during the Depression when little commercial work was available, is his most significant work in the field of art photography.

FIGURE 11

Will Connell

Dust jacket for *In Pictures: A Hollywood Satire.*

New York: T. J. Maloney, Inc., 1937.

30.4×25.4 cm (12×10 in.)

Reed Collection

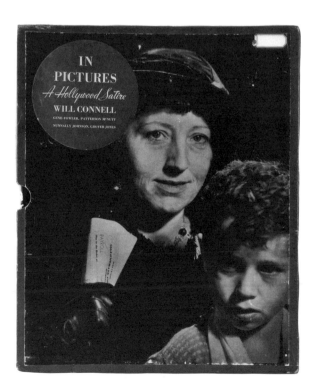

*In Pictures* is a narrative in which Connell's photographs illustrate the text of a supposed "Hollywood conference." The result is a scathing satire of Tinseltown, known well to Connell from years of studio work. In some senses this work comes out of the dramatic narrative tradition of filmmaking which has been discussed earlier, except that Connell's photographs go farther, to comment directly on Hollywood itself. A brochure announcing the book describes it as "a modern Gulliver's travels through the fantastic land of moviedom. And the entire industry is pilloried with its own instruments of torture—ground glass, lens, and shutter."[43] Indeed, Connell used a variety of photographic techniques, particularly montage, to produce striking effects, such as those seen in *Lights* [Cat. 92]. The overlapping lamps appear to move forward and back, their glaring light twisting the human figure until it begins to resemble a Giacometti-like distortion. Images such as *Lights* and *Sound* [Cat. 91] are modernist in every way, yet they are the work of a Pictorialist club member.

<p style="text-align:center">•          •          •</p>

Of all the photographers to be found working in Los Angeles at this period, perhaps the most interesting are the Japanese-Americans. Their work grew out of the Pictorialist tradition, yet they succeeded in creating a number of the most influential modernist photographs. Virtually all were *Issei* (first-generation immigrants), and although a few operated portrait photography studios, most of them typically worked as cooks, salesmen, or clerks. Their photographic community began slowly in the early teens, becoming larger during the 1920s and 1930s with the encouragement of yearly salons sponsored by the *Rafu Shimpo*, the local Japanese-language newspaper. Most of those who exhibited were members of the leading Japanese photography club in Los Angeles, the Japanese Camera Pictorialists of California. The group held an annual members' salon, which was frequently juried by Arthur Kales and Margrethe Mather.

The group maintained rooms for meetings and critiques, and members could develop negatives and enlarge prints in the club darkroom, sometimes working long after midnight when the businesses along Little Tokyo's East First Street were closed. The prints over which they lovingly labored were frequently shot on club outings, usually on Sundays at various park, beach, and mountain locations. A photograph of club members was taken on just such an occasion at Redondo Beach in 1929 [Fig. 12]. In a white coat at the center of the picture is Kaye Shimojima. He was the master photographer of the group, his influence being such that, in the club's first exhibition, he showed fifty-two prints to other members' five or six. He was a greatly respected and demanding teacher. One former member tells of working three years before achieving a negative acceptable to Shimojima.[44]

Shimojima's *Edge of Pond* [Cat. 72] employs the visual devices for which the Japanese became renowned—patterns on flat surfaces in asymmetrical compositions, often taken from high viewpoints.[45] This style was derived from their artistic heritage. The economy of haiku poetry, the "just so" design of flower arranging, and the precision of the tea ceremony all provided inspiration. The patterns in Japanese textiles offered examples for patterns in photography. These visual devices—high viewpoints, elegant patterns, and shadow effects—were essential elements in the visual vocabulary of Japanese fine arts and were known to the Los Angeles Japanese through *ukiyo-e* prints.

In their photographs, high viewpoints were used because they provided the Japanese with a way to represent visual space that was consistent with their artistic heritage. In a conventional Western photograph, one can locate the horizon and plot the way in which each structure appears to recede to a vanishing point (or points) on the horizon. Japanese photographers moved

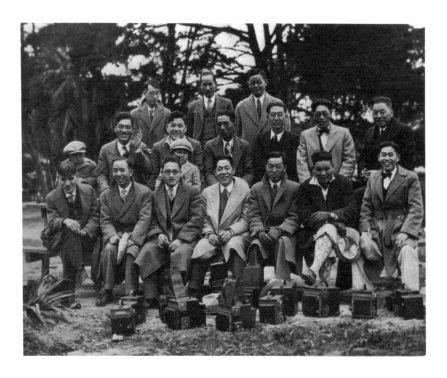

their cameras downward and lifted the horizon out of the picture, thereby lessening the effects of Western perspective. This provided a relatively flat backdrop upon which the two-dimensional elements of line, pattern, and tone (which formed the basis of Japanese art) could be displayed.

Japanese-American photographs were widely exhibited in the salons and reproduced in Pictorialist publications. They had a tremendous influence. By 1925, the editor of *Camera Craft* magazine could write, "It is becoming an accepted belief that American Japanese are not only advancing in abstract pictorialism but are impressing something national, something decidedly characteristic upon our art and in certain cases are actually transforming the stereotypical Salon formula into real novelty."[46]

So many photographs by Japanese-Americans appeared in the *American Annual of Photography 1928* that the editor felt compelled to announce, "In particular, we have included a selection of prints by Japanese photographers in America. . . . The influence of this group on our Pacific coast has put a lasting mark on photography in this country, the repercussions of which are echoing throughout the world."[47]

The importance of the flatness of the picture plane to Japanese-American photographers, along with an emphasis on geometric shape and pattern, paralleled the visual language of modernism. Because of this, their work was seen as promoting modernist views, and indeed, many Japanese experimented with modernist ideas. On the other hand, the general tone of their work—qualities of suggestion and poetry—shared many of the features of the Pictorial tradition.

Some critics found this combination of Pictorialism with modernism uncomfortable: they saw the Japanese style as an assault on conventional Pictorial ideals and referred to such works as "stunts."[48] The avant-garde of Europe were intrigued and supportive, however. Shigemi Uyeda's *Reflections on the Oil Ditch* [Cat. 90], for example, was one of the most reproduced photographs of its day. In addition to its reproduction in several American publications, a variant appeared in Moholy-Nagy's landmark book of 1938, *The New Vision*. The influence of Japanese-

American photography extended even to the Soviet Union, where Uyeda's *Oil Ditch* was published in *Soviet Foto* alongside works by German and Czechoslovakian photographers.[49]

Among the most striking images produced by the Los Angeles Japanese were those of still-life subjects. Hiromu Kira, who occasionally attended club meetings, produced masterful still lifes using dishware and paper cranes, in photographs such as *Curves* [Cat. 88] and *Paper Bird* [Cat. 87]. They are exquisite studies in placement. He described in *Camera Craft* how he came to create his first paper bird photograph:

> Incidentally one day I saw a girl folding the Paper Cranes. I was much attracted by the unusual form of the lines and decided to work at it. But it was not a trifling matter to learn in what arrangement this subject should be handled. Preferring the streetcar to automobile in the rush hours of morning and evening, I rode on the crowded streetcar, yet even while riding in the confusion and chaos, I did not waste a moment for trying to think out some idea for the subject. The few moments in the restaurant while waiting were used to that end. And after about a week's restless effort, came a simple idea to mind. That was to use three differently toned cardboards. A large cardboard was placed on the floor and two smaller ones on top of it . . . and the little paper bird was set on lastly. I set the camera facing downward and proceeded.[50]

Still lifes were created by other Japanese Camera Pictorialist club members as well: K. Asaishi's *The Books* [Cat. 85] is a pale, subtle, cubistic image, providing multiple views of the subject;[51] and J. T. Sata created a Constructivist arrangement of triangles and balls with a dense overlay of pattern [Cat. 84].

One of the most unexpected images is *Perpetual Motion* [Cat. 90] by club member A. Kono. Unfortunately, as is the case with so much regarding the Los Angeles Japanese, little is known about Kono or the making of this image. It is, however, a remarkable achievement of abstract art by any standards, especially for an unknown photographer working in an unfamiliar cultural environment.

The *Shakudo-Sha* was another group in Little Tokyo interested in modern art. Members were young painters and poets of the Japanese intellectual community who were committed to maintaining time-honored Japanese traditions while simultaneously furthering modern ideas.[52] Perhaps the group's most noteworthy accomplishment was the sponsorship of four exhibitions of Edward Weston's photographs between 1921 and 1931. Weston's notes on the second show of the series compared it to an exhibition that had been organized by a Los Angeles women's group:

> Exhibit in Los Angeles given before a Japanese Club on East First Street, August, 1925.
>      The exhibit is over. Though weary, I am happy. In three days I sold prints to the amount of $140.—American Club Women bought in two weeks $00.00—Japanese men in three days bought $140.00! One laundry worker purchased prints amounting to $52.00—and he borrowed the money to buy with.[53]

The exhibitions in Little Tokyo had been arranged by Toyo Miyatake, a member of the *Shakudo-Sha*. Weston's work was greatly admired by the Japanese, and his presence encouraged area photographers, including Miyatake. Weston instructed Miyatake in matters of composition, cautioning him against relying on conventional rules. Miyatake recalled years later that "he told me, after you study composition, just forget about it . . . the composition is [in] your

stomach."[54] Weston further suggested that Miyatake reexamine his native artistic heritage, particularly Japanese woodblock prints, as well as study the work of such modern artists as Brancusi.

Weston acknowledged his influence on the photographers of the Japanese community while recording a somewhat self-serving reaction to the 1927 International Salon in Los Angeles: "After noting the numbers of four photographs that had some value I referred to the catalogue, finding that each one was by a Japanese. Perhaps my exhibit in the Japanese colony has borne some fruit—I could feel my influence."[55] Weston's effect on Miyatake can be seen in Miyatake's abstract study of the top of a tombstone [Cat. 86], where the stone triangles mimic Weston's renowned attic pictures.

Miyatake's most interesting photographs were influenced more directly by the Japanese dancer Michio Ito, and it was he who taught the photographer most about movement and light. Miyatake became Ito's lighting assistant in 1929 and later his official photographer. In the early 1930s Miyatake began making abstract studies of the dancer, and images such as *Reflections from the Filament* [Cat. 89] are dynamic examinations of the unity of light and motion.

Sadly, the work of this vital group came to an abrupt end following the bombing of Pearl Harbor. Americans of Japanese descent were forced to leave their homes and businesses for inland relocation camps where they spent the war years in confinement. Each evacuee was allowed only one trunk of personal belongings, and most trunks were filled with practical necessities such as clothing. Evacuees had little recourse but to sell items of value such as cameras, often at a fraction of their worth, and the art photographs themselves were often simply discarded. Many others put their photographs and equipment into storage, only to discover after the war that the facilities had been ransacked and the items damaged or stolen.

·           ·           ·

The study of the later stages of Pictorialism, especially in the work of Southern Californian photographers, reveals a rich vein of important and little-known material. To dismiss Pictorialism as an artistic movement out of step with the forward march of modernism, as many art historians have done, is seriously to underestimate both its significance and its accomplishments. Pictorialism in California both nourished and legitimized photography as an expressive art and was the form in which its most celebrated early examples were created. Gradually, over the years, Pictorialism also served as an arena for the cautious testing of modernist ideas. Eventually new photographic ideas were used by an ever-increasing number of amateurs who blended Pictorial traditions with modern approaches. Through Pictorialism, modernism became not the privilege of a select few but the practice of many.

# NOTES

1   Will Connell, introduction to *The 31st International Salon of Photography,* The Camera Pictorialists of Los Angeles, 1950, n.p.

2   "Pope Stieglitz," Editorial in *Photo-Era* 12 (July 1904): 124; "Pictorialists vs. New York Salon," editorial in *Photo-Era* 13 (October 1904): 186.

3   Frank Roy Fraprie, "The First American Photographic Salon in New York," *Photo-Era* 13 (December 1904): 223. *Photo-Era* reported that 350 prints were actually shown because of limited wall space.

4   The London Salon and the Salon of the Royal Photographic Society were models for the First American Salon.

5   The other organization was the Metropolitan Camera Club of New York, with Curtis Bell as president.

6   "Louis Fleckenstein," Editorial in *Photo-Era* 24 (January 1910): 47.

7   Unpublished manuscript in a private collection, repr. in Stephen White, *Louis Fleckenstein*, exhibition catalogue (Stephen White's Gallery, 1977).

8   Ibid.

9   Quoted in Margery Mann, *California Pictorialism* (San Francisco: San Francisco Museum of Modern Art, 1977): 20.

10  "Los Angeles Camera Club," Editorial in *Photo-Era* 26 (April 1911): 213.

11  Ibid.

12  "The Southern California Camera Club," Editorial in *Photo-Era* 37 (September 1916): 152.

13  Ibid.

14  Fred Archer, "The Camera Pictorialists of Los Angeles," *The Pictorialist* (Los Angeles, 1931): 4.

15  Will Connell, unpublished holograph manuscript, Will Connell Collection, Department of Special Collections, University Research Library, UCLA. Some of the other Camera Pictorialist club members included Kenneth Alexander, Jack Barsby, William M. Clarke, Fred R. Dapprich, C. K. Eaton, Phil Townsend Hanna, Milton Inman, Charles Kerlee, Victor Matson, N.P. Moerdyke, John C. Stick, Clark W. Thomas, Bob Wallace, and Ernest Williams (one of the founders), none of whom are represented in this exhibition catalogue.

16  Ibid.

17  Louis Fleckenstein, "The First International Photographic Salon," *Photo-Era* 40 (March 1918): 163.

18  Connell, *The 31st International Salon of Photography,* n.p.

19  Fleckenstein, *Photo-Era* 40: 163.

20  Louis Fleckenstein, "Why I Am a Pictorial Photographer," *Photo-Era* 62 (January 1929): 3.

21  W. R. Bland, "Observations on Some Pictures of the Year," *Photograms of the Year, 1916* (London, 1917): 14.

22  Arthur F. Kales, "The Second International Salon at Los Angeles," *Photo-Era* 62 (February 1919): 59.

23  Sigismund Blumann, "Arthur F. Kales, F.R.P.S.," *Photo-Era* 2 (November 1934): 520.

24  The Morgan Dancers were one of many dance troupes in Los Angeles at the time; Kales's wife was a Denishawn dancer.

25  William Mortensen, *Monsters and Madonnas: A Book of Methods* (San Francisco, 1936): n.p.

26  Frank Crowninshield, foreword to *Pictorial Photography in America* 5 (New York, 1929), unpaginated. Florence Kemmler's *Trapeze Act* [Cat. 83] and Karl Struss's *Sails* [Cat. 70] were both reproduced in this issue.

27  Quoted in Ben Maddow, *Edward Weston: Fifty Years* (New York: 1973): 34.

28  Ibid.

29  Weston J. Naef, "Edward Weston: The Home Spirit and Beyond," in Susan Danly and Weston J. Naef, *Edward Weston in Los Angeles* (San Marino, 1986): 21. Weston also saw the work of Anne Brigman, Karl Struss, and Clarence White.

30  F. C. Tilney, "Pictorial Photography in 1921," *Photograms of the Year, 1921* (1922): 17.

31  The Group f/64 exhibition included members Ansel Adams, Imogen Cunningham, John Paul Edwards, Sonia Noskowiak, Henry Swift, Willard Van Dyke, and Edward Weston, along with guest exhibitors Preston Holder, Consuelo Kanaga, Alma Lavenson, and Brett Weston.

32  Ansel Adams, "An Exposition of My Photographic Technique," *Camera Craft* 41 (January 1934): 19.

33  William Mortensen, "Venus and Vulcan: An Essay on Creative Pictorialism: Interpretations of Reality," *Camera Craft* 41 (March 1934): 106.

34  Archer, plate 95.

35  Nicholas Haz, "Picture Analysis," *American Photography* 31 (October 1937): 716.

36  Ibid. Haz indicates that Archer's print was done "twenty years ago."

37  A small collection of Archer's prints is housed at the Frances Howard Goldwyn Hollywood Regional Branch Library, Special Collections.

38  Tom Maloney, ed., "Will Connell," *U.S. Camera International Annual 1963* (1962): 115.

39  Merle Armitage, "The Spirit of the Machine," in unidentified newspaper, 20 June 1930, Will Connell Collection, UCLA.

40   Zeitlin gave Edward Weston his first commercial showing in his bookstore.

41   Jake Zeitlin, *Books and the Imagination: Fifty Years of Rare Books*, oral history, 1980, Department of Special Collections, University Research Library, UCLA.

42   Philippe Halsman, tribute in *U.S. Camera International Annual 1963* (1962): 110.

43   *In Pictures: A Hollywood Satire,* advertising brochure, c. 1937, Will Connell Collection, UCLA, n.p.

44   Information regarding Japanese-American photographers came from interviews with Harry Hayashida, Ichiro Itani, Kaneshige Kato, and Hiromu Kira, 1981–1985; from interviews with the families of various other Japanese photographers, 1981–1993; exhibition catalogues of the Japanese Camera Pictorialists of California, 1926–1940.

45   This print was once owned by Karl Struss.

46   Sigismund Blumann, "Our Japanese Brother Artists," *Camera Craft* 32 (March 1925): 109.

47   Frank Roy Fraprie, "Our Illustrations," *The American Annual of Photography, 1928* (1927): 136.

48   See F. C. Tilney, "American Work at the London Exhibitions," *American Photography* 21 (December 1927): 666–668, for a contemporary appraisal that is demeaning to the Japanese-American photographic style.

49   See *Soviet Foto* no. 12, 1927.

50   Hiromu Kira, "Still Life Photography," *Camera Craft* 35 (August 1928): 359.

51   Asaishi would carefully draw his compositions in advance of photographing them.

52   Information regarding the *Shakudo-Sha* was obtained from an interview with Hiroshi Namadzue in 1983.

53   Nancy Newhall, ed., *The Daybooks of Edward Weston, Volume I. Mexico* (New York, 1961), 121–122. Photographs and writings by Edward Weston © 1981, Center for Creative Photography, Arizona Board of Regents. Quoted by permission.

54   Toyo Miyatake, *A Life in Photography: The Recollections of Toyo Miyatake,* interview by Enid H. Douglas (Claremont, 1978), 56.

55   Newhall, *Daybooks of Edward Weston, Volume II. California*, 8. Copyright 1981, Center for Creative Photography, University of Arizona, Arizona Board of Regents. Quoted by permission.

# SOUTHERN CALIFORNIA

PLATES

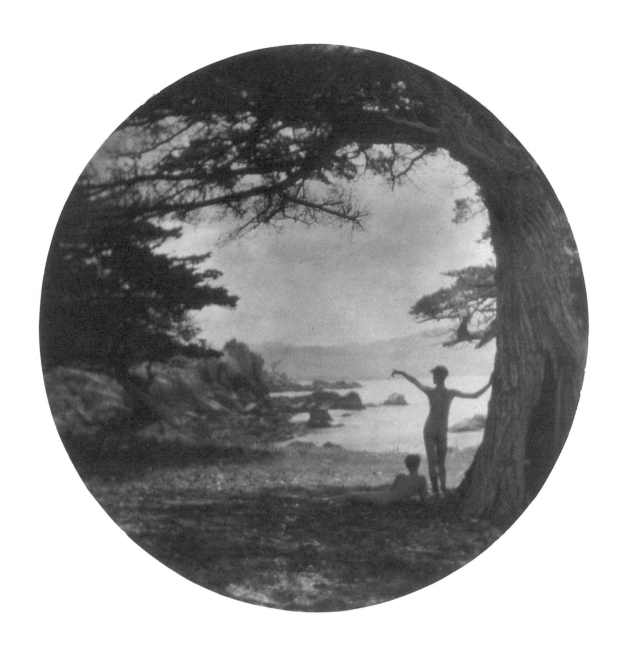

43
Otis Williams
*Utopia, Northeast of*
*Cypress Point,* 1928
Toned bromide print
20.1 cm diameter (7²⁹/₃₂ in.)
The Henry E. Huntington
Library and Art Gallery

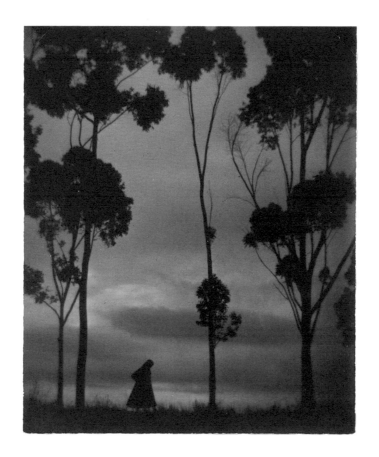

4 4
Karl Struss
*Storm Clouds,* 1921
Toned bromide print
10.9 × 9.1 cm (4⁹/₃₂ × 3¹⁹/₃₂ in.)
Collection of Craig Struss Rhea

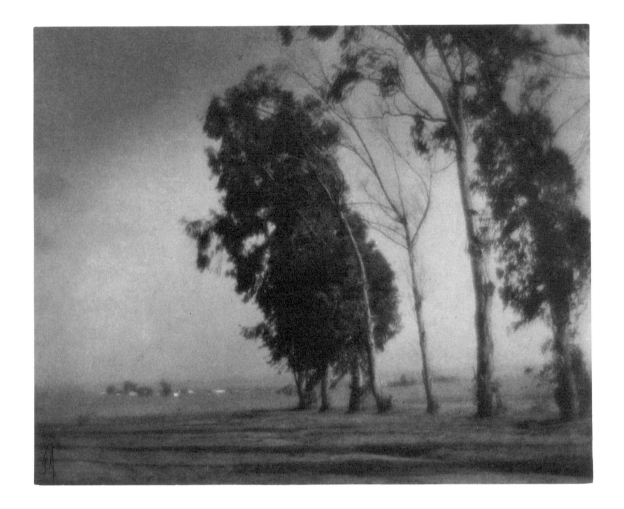

45
Fred Archer
*Near Clover Field,* n.d.
Toned bromide print
18.5 × 23.4 cm (7⁹⁄₃₂ × 9⁷⁄₃₂ in.)
The Henry E. Huntington
Library and Art Gallery

46
Kaye Shimojima
*Dusty Trail*, c. 1921
Toned bromide print
(possibly carbon print)
36.6×45.5 cm (14¹³⁄₃₂ × 17²⁹⁄₃₂ in.)
Reed Collection

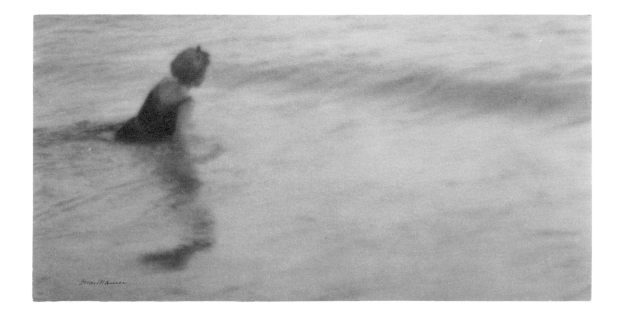

47
Oscar Maurer
*The Wave*, n.d.
Toned bromide print
9.7 × 19.3 cm (3¹³⁄₁₆ × 7¹⁹⁄₃₂ in.)
Wilson Collection

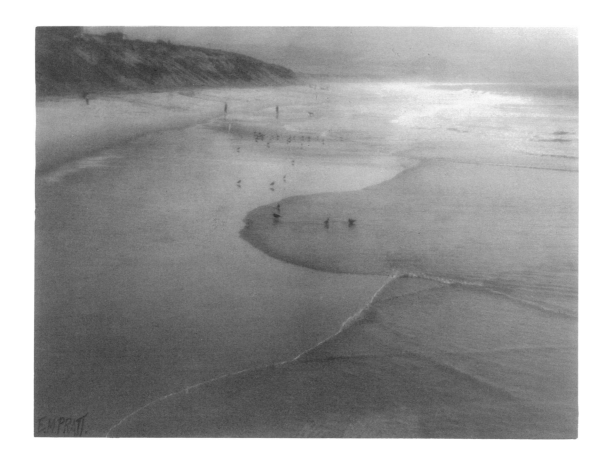

48
Ernest M. Pratt
*Ebb Tide*, c. 1925
Toned bromide print
15.2 × 20.8 cm (6 × 8³⁄₁₆ in.)
The Henry E. Huntington
Library and Art Gallery

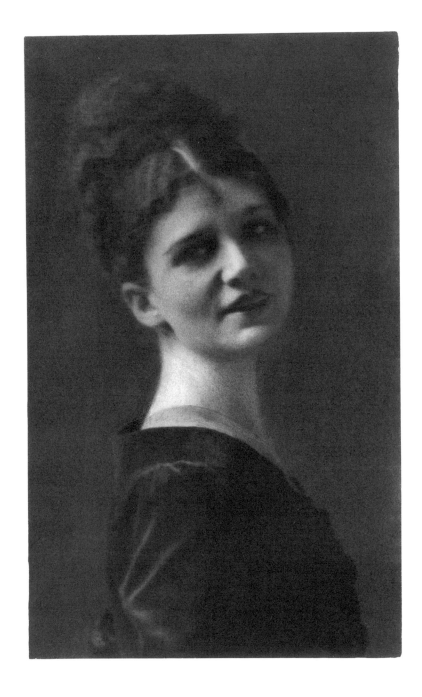

4 9
Louis Fleckenstein
*The Girl from Delhi,* c. 1920
Toned bromide print
34.5×21.3 cm (13¹⁹⁄₃₂×8⅜ in.)
Collection of Leonard and
Marjorie Vernon

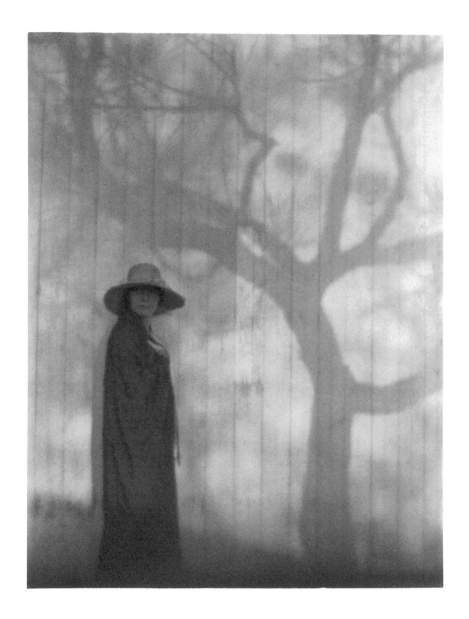

50
Edward Weston
*Prologue to a Sad Spring,* 1920
Platinum print
23.9 × 18.5 cm (9¹⁵/₁₆ × 7⁹/₃₂ in.)
Collection of Leonard and
Marjorie Vernon
© 1981 Center for
Creative Photography,
Arizona Board of Regents

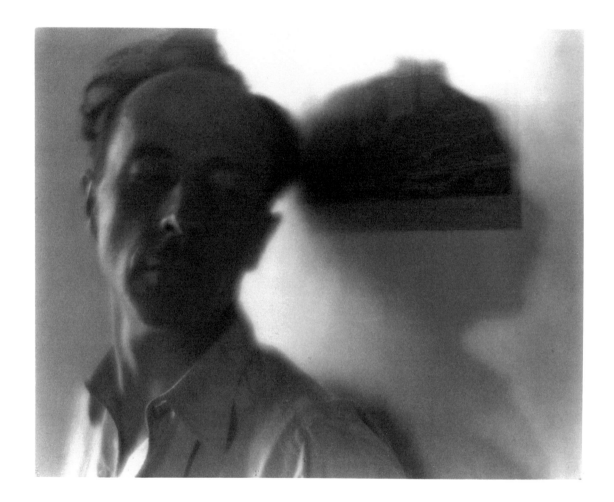

51
Margrethe Mather
*Edward Weston,* 1921
Platinum print
19.1 × 24.1 cm (7½ × 9½ in.)
The J. Paul Getty Museum

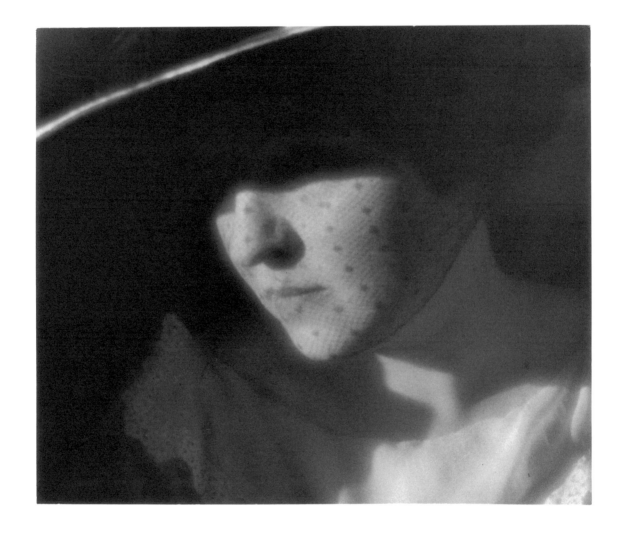

5 2
Louis Fleckenstein
*The Veiled Lady,* c. 1920
Toned bromide print
18.3×22.1 cm (7⁷/₃₂ × 8²³/₃₂ in.)
Collection of Leonard and
Marjorie Vernon

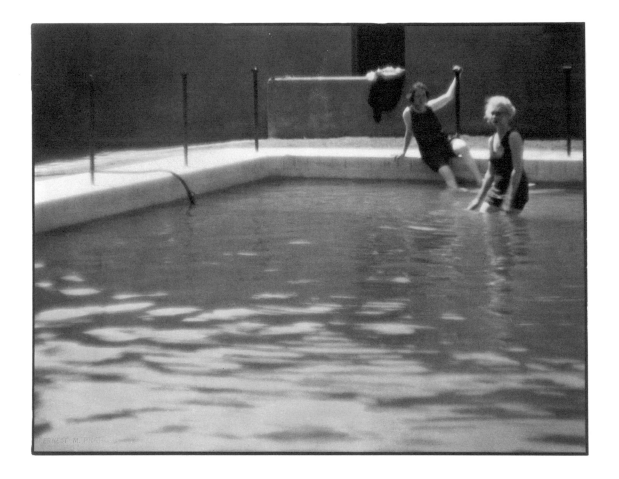

53
Ernest M. Pratt
*The Swimming Pool,* c. 1920
Bromide print
26.2 × 35.1 cm (10⁵⁄₁₆ × 13¹³⁄₁₆ in.)
Collection of Leonard and
Marjorie Vernon

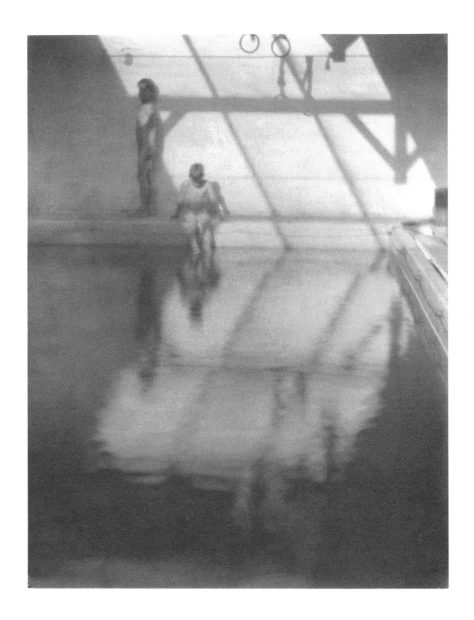

54
Edward Weston
*Bathing Pool,* 1919
Platinum print
24.9 × 19.1 cm (9¹³⁄₁₆ × 7½ in.)
Collection of Leonard and
Marjorie Vernon
© 1981 Center for
Creative Photography,
Arizona Board of Regents

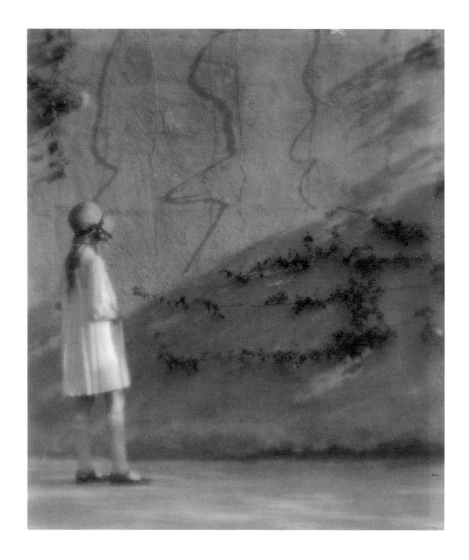

5 5
Edward P. McMurtry
*Shadow Faces*, 1932
Carbro print
18.3 × 16 cm (7⁷/₃₂ × 6⁹/₃₂ in.)
The Henry E. Huntington
Library and Art Gallery

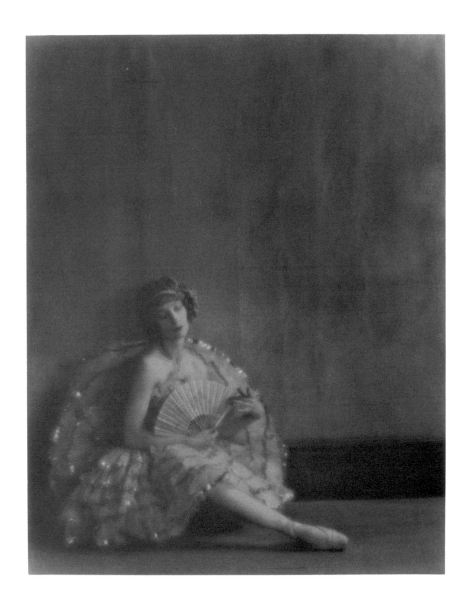

56
Fred William Carter
*Untitled*, c. 1925
Toned bromide print
24.9 × 19.8 cm (9¹³⁄₁₆ × 7²⁵⁄₃₂ in.)
Reed Collection

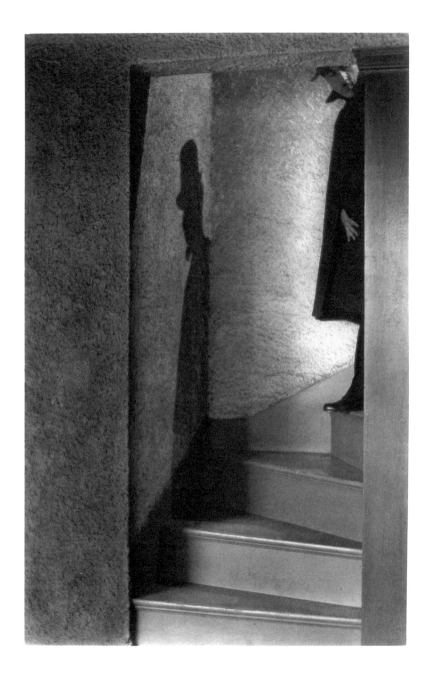

5 7
Margrethe Mather
*Untitled* [Portrait of
Edward Weston], 1921
Platinum print
24.1 × 15.6 cm (9½ × 6⅛ in.)
The J. Paul Getty Museum

58
Edward Weston
*Untitled* [Betty Brandner
with Rectangles], 1920
Platinum print
19.0 × 24.2 cm (7½ × 9⁹⁄₁₆ in.)
The J. Paul Getty Museum
© 1981 Center for
Creative Photography,
Arizona Board of Regents

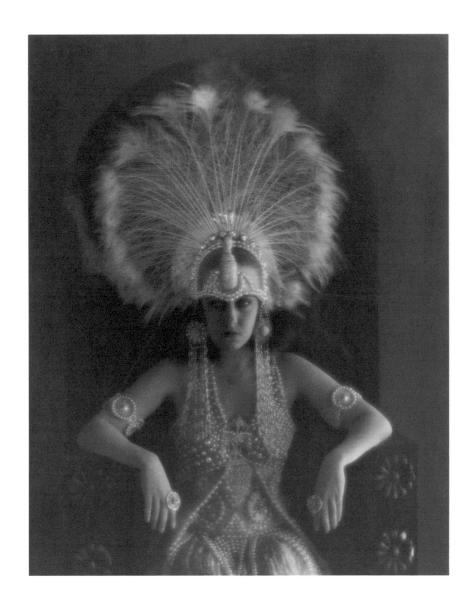

59
Arthur F. Kales
*Untitled* [Gloria Swanson in
*Male and Female*], 1919
Toned bromide print
34.3 × 26.9 cm (13½ × 10¹⁹⁄₃₂ in.)
Collection of Earle A. Kales

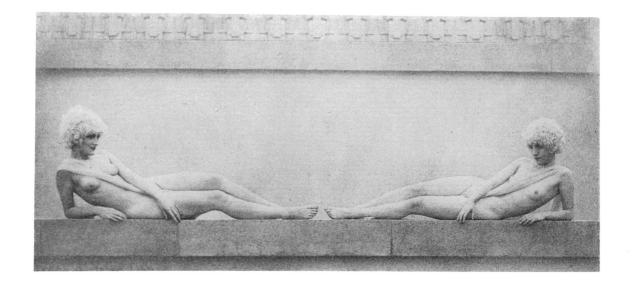

6 0
Arthur F. Kales
*Cameo,* c. 1922
Bromoil transfer print
paper: 28.2×21.6 cm (11⅛×8½ in.);
image: 6.8×15.2 cm (2.7×5.9 in.)
Reed Collection

6 1
Louis Fleckenstein
*Untitled* [Portrait of
Arthur Kales], c. 1920
Toned bromide print
25.1 × 19.8 cm (9⅞ × 7²⁵⁄₃₂ in.)
Collection of Tom Jacobson

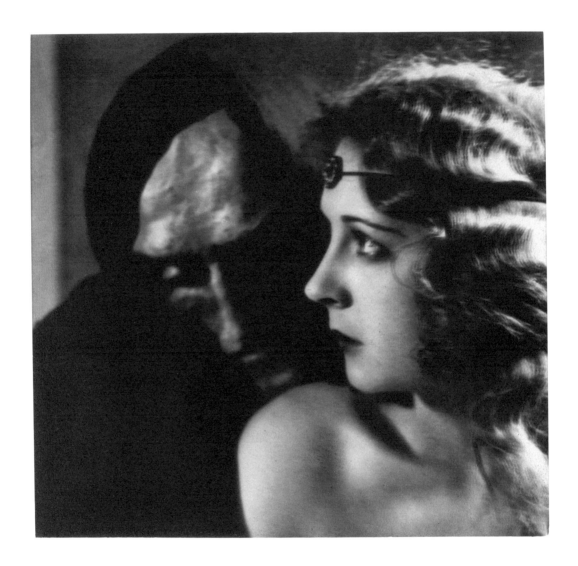

6 2
Robert Officer
*Youth's Shadow,* c. 1933
Toned bromide print
19.6×21.1 cm (7²³⁄₃₂×8⁵⁄₁₆ in.)
Wilson Collection

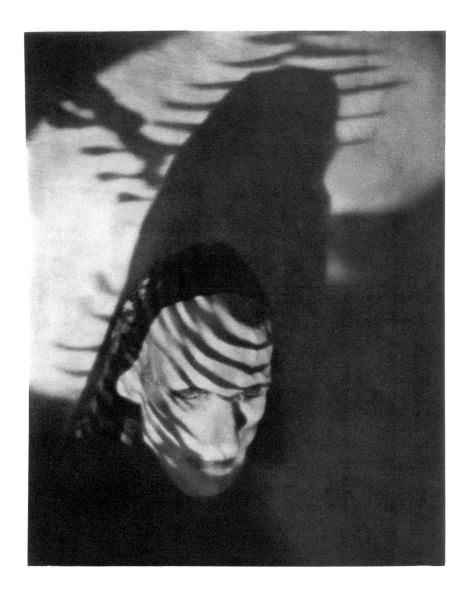

6 3
Arthur F. Kales
*Crime,* 1924
Bromoil transfer print
34.3×27.4 cm (13½×10-25/32 in.)
Reed Collection

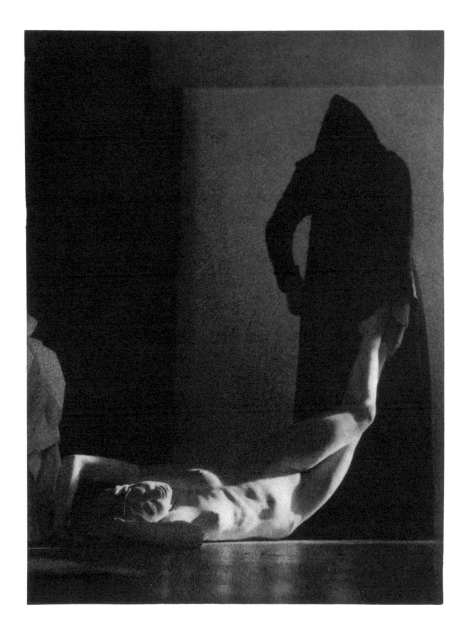

6 4

William Mortensen

*Death of Hypatia,* c. 1926

Bromide print (textured screen)

paper: 34.3×22.4 cm (13½×8¹³⁄₁₆ in.);

image: 18.8×14.5 cm (7¹³⁄₃₂×5²³⁄₃₂ in.)

Collection of Tom Jacobson

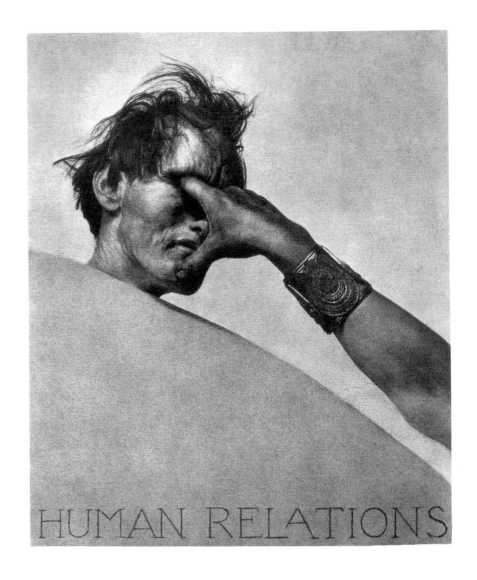

6 5
William Mortensen
*Human Relations,* c. 1932
Silver print (textured screen;
composite negative)
43.2×35.6 cm (17×14 in.)
Stephen White Collection (II)

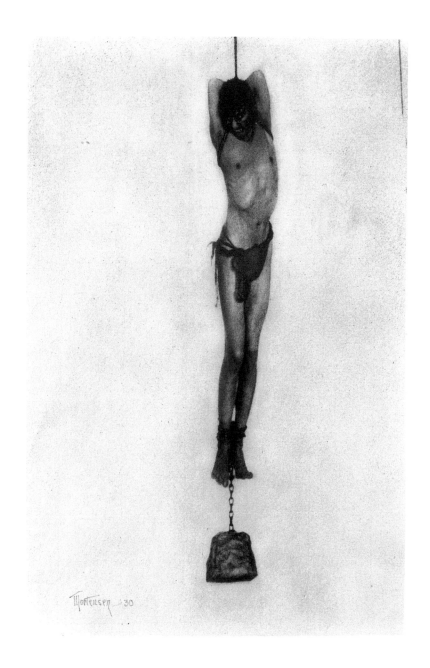

66
William Mortensen
*Self-Portrait,* 1930
Bromoil transfer print
(hand-colored?)
25.4 × 16.5 cm (10 × 6½ in.)
Wilson Collection

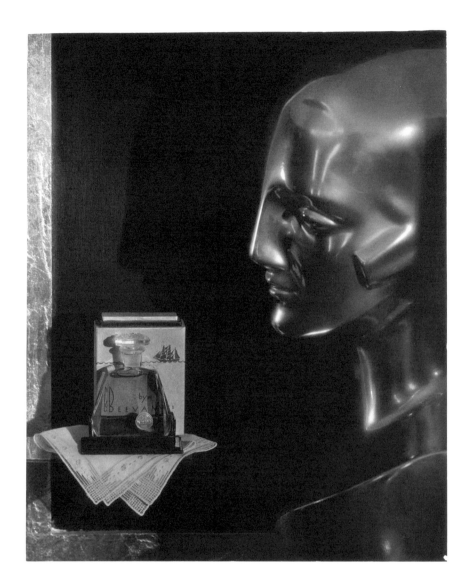

6 7
James N. Doolittle
*Untitled* [advertisement],
c. 1930
Gold-toned bromide print
41.7 × 34.3 cm (16$^{13}$⁄$_{32}$ × 13½ in.)
Collection of Tom Jacobson

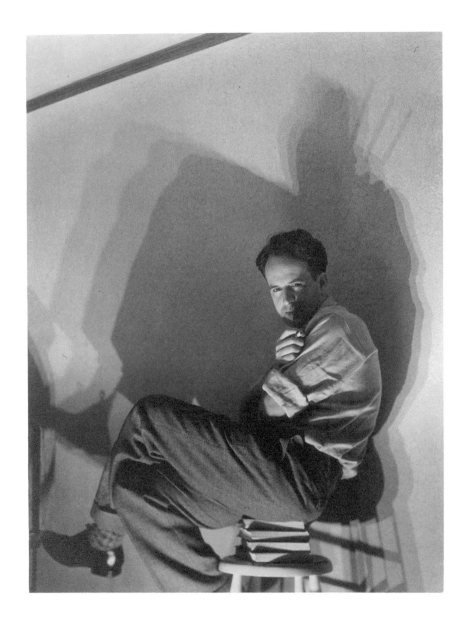

68
Lynton Vinette
*Self-Portrait,* 1932
Bromide/chloride print
33×25.4 cm (13×10 in.)
Reed Collection

69
Edward P. McMurtry
*On the Elbe*, c. 1930
Carbro print
17.5 × 22.6 cm (6⅞ × 8²⁹⁄₃₂ in.)
The Henry E. Huntington
Library and Art Gallery

7 0
Karl Struss
*Sails,* 1929
Toned bromide print
34.8 × 27.4 cm (13²³⁄₃₂ × 10²⁵⁄₃₂ in.)
Collection of Leonard and
Marjorie Vernon

71
Julius Cindrich
*Evening, Green Bay*, c. 1925
Toned bromide print
27.2 × 34.7 cm (10²³⁄₃₂ × 13²¹⁄₃₂ in.)
Reed Collection

72
Kaye Shimojima
*Edge of Pond,* c. 1928
Toned bromide print
34.6 × 26.9 cm (13⁷/₁₆ × 10½ in.)
The Los Angeles County
Museum of Art,
Gift of Karl Struss

73
Shinsaku Izumi
*Tunnel of Night*, c. 1931
Toned bromide print
34.3 × 27.2 cm (13¼ × 10¾ in.)
The Los Angeles County
Museum of Art

74
Shigemi Uyeda
*Reflections on the Oil Ditch*, c. 1924
Toned bromide print
33.3×25.7 cm (13⅛×10⅛ in.)
Collection of the Uyeda family

7 5

Will Connell

*A Study in Diagonals,* 1925

Bromide print

33.8×21.3 cm (13⁵⁄₁₆×8⅜ in.)

The Henry E. Huntington

Library and Art Gallery

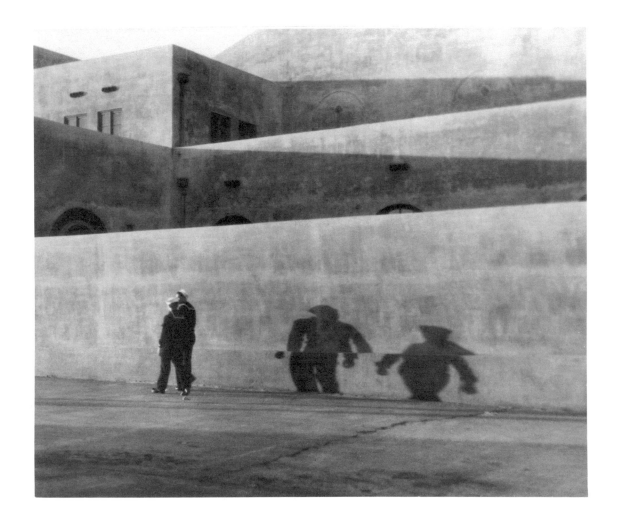

76
Roland E. Schneider
*Grotesque Shadows*, c. 1929
Chlorobromide print
27.9×34.0 cm (11×13⅜ in.)
Collection of Tom Jacobson

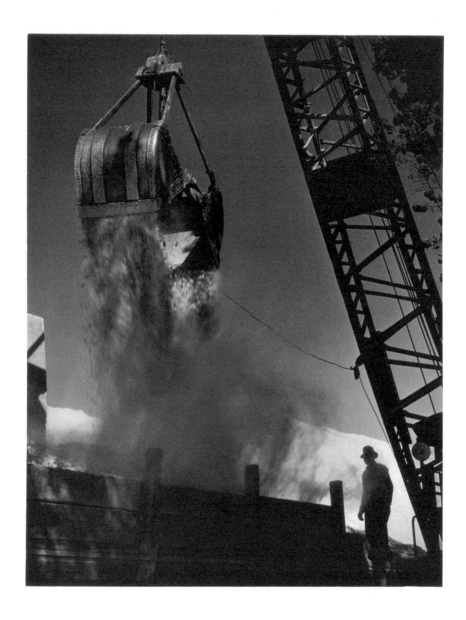

77
Fletcher O. Gould
*Shovel*, c. 1930
Toned bromide print
34.0 × 26.7 cm (13⅜ × 10½ in.)
Collection of Leonard and
Marjorie Vernon

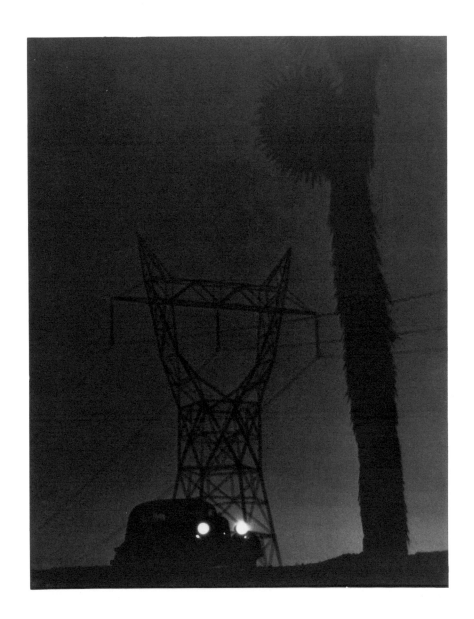

78
Kirby Kean
*Night Scene near Victorville,*
c. 1937
Gelatin silver print
33.5 × 25.9 cm (13³⁄₁₆ × 10³⁄₁₆ in.)
The J. Paul Getty Museum

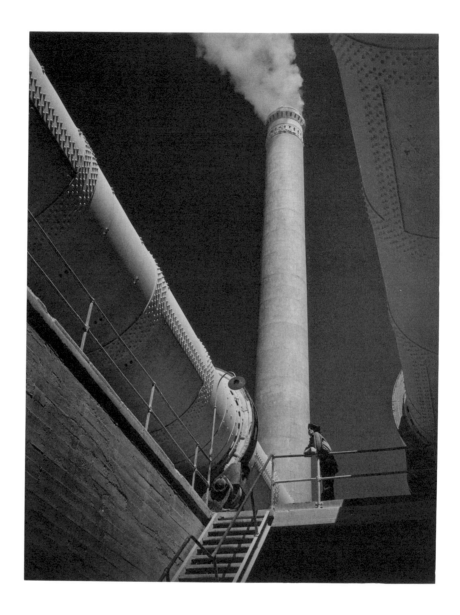

79
Fletcher O. Gould
*Untitled*, c. 1930
Toned bromide print
35.6 × 27.9 cm (14 × 11 in.)
Collection of Leonard and
Marjorie Vernon

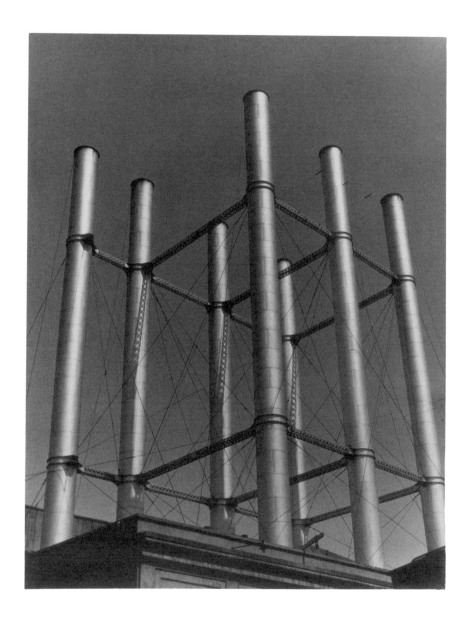

80
Florence B. Kemmler
*Symbols of Progress*, c. 1930
Chlorobromide print
35.1 × 27.4 cm (13$^{13}$⁄$_{16}$ × 10$^{25}$⁄$_{32}$ in.)
Collection of Tom Jacobson

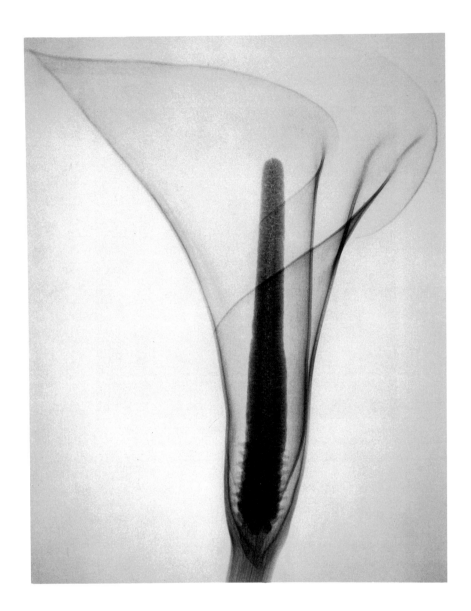

8 1
Dain Tasker
*Lily—An X-Ray*, 1930
Toned silver print
from radiograph
29.8×24.8 cm (11¾×9¾ in.)
Collection of Gorden L. Bennett
Photo: Brian Merrett, MMFA

82
Anne Brigman
*Untitled* [Sand Erosion], c. 1931
Silver print
19.3×24.6 cm (7$^{19}$/$_{32}$×9$^{11}$/$_{16}$ in.)
Wilson Collection

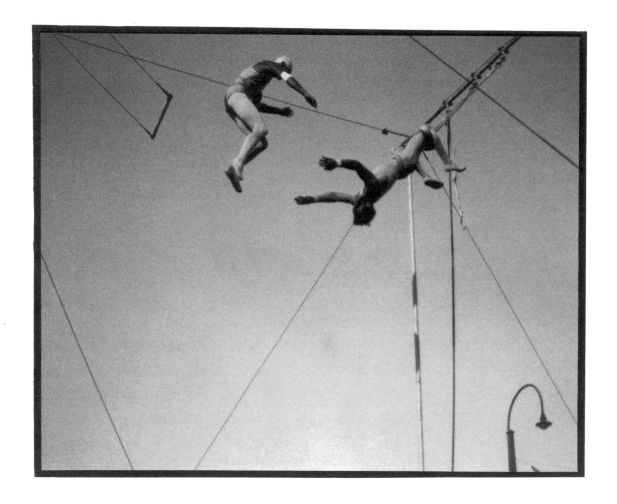

83
Florence B. Kemmler
*Trapeze Act*, c. 1928
Chlorobromide print
18 × 23.1 cm (7³/₃₂ × 9³/₃₂ in.)
Collection of Tom Jacobson

84
J. T. Sata
*Untitled*, 1926
Toned bromide print
14.6×21 cm (5¾×8¼ in.)
Collection of Frank T. Sata

85
K. Asaishi
*The Books,* c. 1926
Bromide print
18.2×22.4 cm (7⅛×8⅞ in.)
Collection of Togo Tanaka

86
Toyo Miyatake
*Untitled*, 1925
Bromide print
21.5×33.7 cm (8½×13½ in.)
Collection of the Miyatake family

87
Hiromu Kira
*Paper Bird,* 1928
Toned bromide print
25.9 × 32.8 cm (10³⁄₁₆ × 12²⁹⁄₃₂ in.)
The Henry E. Huntington
Library and Art Gallery

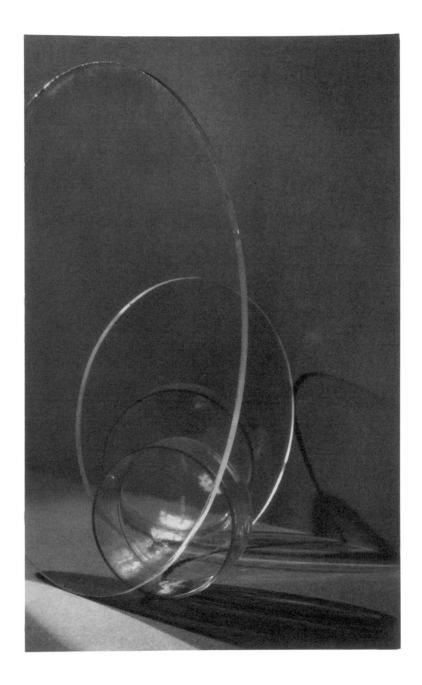

88
Hiromu Kira
*Curves*, c. 1930
Toned bromide print
34.3 × 21.6 cm (13½ × 8½ in.)
Collection of Audrey and
Sydney M. Irmas

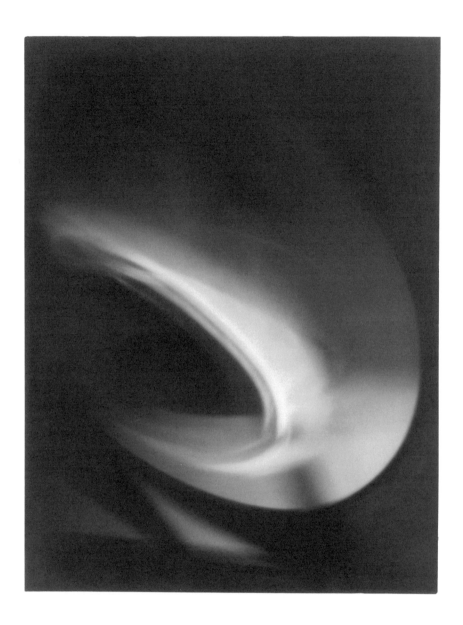

89
Toyo Miyatake
*Reflection from the Filament*, 1931
Toned bromide
31.1×23.5 cm (12¼×9¼ in.)
Collection of the Miyatake family

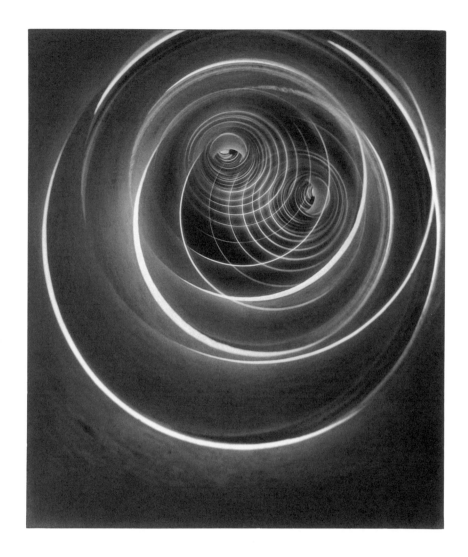

9 0
A. Kono
*Perpetual Motion,* 1931
Toned bromide print
30.7 × 26.4 cm (12³⁄₃₂ × 10¹³⁄₃₂ in.)
Reed Collection

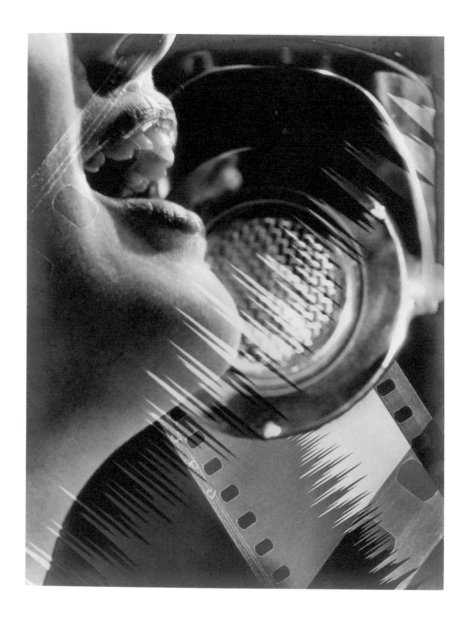

9 1
Will Connell
*Sound,* 1936
Silver print
34.3 × 26.7 cm (13½ × 10½ in.)
Stephen White Collection (II)

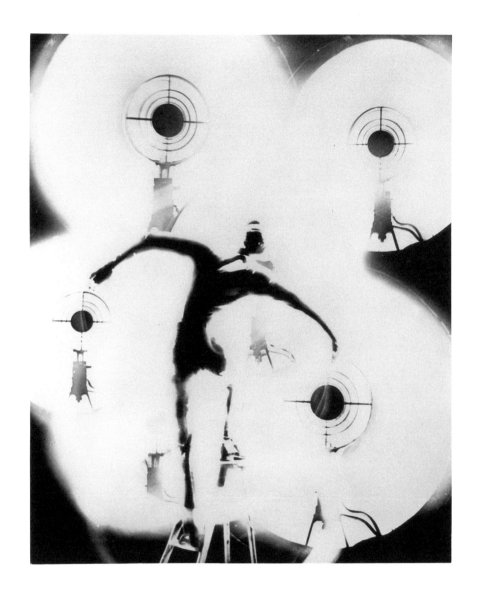

92
Will Connell
*Lights*, c. 1933
Silver print
35.6×27.9 cm (14×11 in.)
Reed Collection

# BIOGRAPHIES

**Ansel Adams** (1902–1984)
Ansel Easton Adams was born February 20, 1902, in San Francisco. In 1983 he was described in the *MacMillan Biographical Encyclopedia of Photographic Artists and Innovators* as "without question the most well-known photographer in America, if not the world." In 1930 he gave up a promising career in music to pursue photography full time. He was a founder of Group f/64 and a disciple of Edward Weston. For his efforts on behalf of the natural environment, a mountain and a wilderness area in the Sierra Nevada were named for him. Adams died in Carmel on April 22, 1984.

**Fred Archer** (1889–1963)
Fred Archer was born in Georgia. He was a member of the Los Angeles Camera Club and, in 1914, became a founding member of the Camera Pictorialists of Los Angeles. From the mid-1930s through most of the 1940s Archer was director of the Camera Pictorialists of Los Angeles, and he remained the only photographer who was an active member until the club disbanded around 1950. He was a frequent salon exhibitor and lectured at camera clubs throughout the West. He wrote a number of articles and one book, *Fred Archer on Portraiture*. Archer taught at the Art Center School (now Art Center College of Design) in Pasadena and later ran the Fred Archer School of Photography in Los Angeles.

**Laura Adams Armer** (1874–1963)
Laura Adams Armer was born in Sacramento on January 12, 1874. She grew up in San Francisco and studied at the Mark Hopkins Institute of Art (now the San Francisco Art Institute). She was a leading member of a group of professional women photographers (including Adelaide Hanscom and Emily Pitchford) in the Bay Area. She exhibited several images at the First San Francisco Photographic Salon of 1900 and for many years exhibited in other local and national salons. She closed her San Francisco studio in March 1902 to marry the painter Sidney Armer. She continued to work in photography and in the 1920s turned to documentary cinema. She died in Vacaville, California, on March 3, 1963.

**K. Asaishi**
K. Asaishi was born in Japan. He was a member of the Japanese Camera Pictorialists of California, a Los Angeles area club. He exhibited during the early and mid-1920s, primarily in salons presented in the Japanese communities of Los Angeles and Seattle. Asaishi was one of the key exponents of modernism in the Japanese photographic groups on the West Coast. He returned to Japan in 1927.

**Anne W. Brigman** (1869–1950)
Anne Brigman was born in Hawaii on December 3, 1869, and moved to California at the age of sixteen. In 1894 she married a sea captain, Martin Brigman. She trained as a painter but turned to photography around 1902. She was one of two original members of the Photo-Secession from California. She eventually became a Fellow, the only photographer from the West to hold such an honor. She worked in San Francisco and was one of the few photographers whose career continued to flourish after the 1906 earthquake and fire. Brigman moved to the Long Beach area around 1929. She is renowned for her photographs of nudes in the California landscape, in which she used spectacular locations such as the Sierra Nevada. She died in Eagle Rock, near Los Angeles, in 1950.

**Francis Joseph Bruguière** (1879–1945)
Francis Bruguière was born in 1879 in San Francisco. He grew up in a wealthy family and attended school on the East Coast, where he studied music, poetry, painting, and photography. Bruguière was originally a painter, but photography became his priority after he met Frank Eugene and Alfred Stieglitz in New York in 1905. Financial reversals following the 1906 San Francisco earthquake compelled him to turn professional. After cochairing the photographic exhibit selection for the 1915 Panama-Pacific International Exposition in San Francisco, Bruguière moved to New York. Today he is best known for his abstract photographs dating from the 1920s. He died of pneumonia in 1945.

**Fred William Carter** (1897–1974)
Fred William Carter was born in California in 1897 and lived in the state all his life. He was something of a bohemian and, at least for a period, earned his living as a dance hall musician. He was a founding member of a small club in Covina (east of Los Angeles) called the Tripod Camera Pictorialists. He died in Santa Monica, where he had lived for a number of years among the local artists.

**Julius Cindrich** (1890–1981)
Julius Cindrich began as an amateur photographer in the early 1920s and later became a professional advertising and Hollywood studio photographer. He was a member of the Southern California

Camera Club and the Camera Pictorialists of Los Angeles. He also taught photography at the Art Center School in Los Angeles during the 1930s. He died in Woodland Hills, California.

### Will Connell (1898–1961)

Will Connell was born in McPherson, Kansas, in 1898. He was a self-taught photographer who became nationally known for his commercial photography. He became associated with the Los Angeles Camera Club around 1917. Later, he was a member of the Camera Pictorialists of Los Angeles and was its leading force during the mid- to late 1930s. He was also a teacher and founded the photography department at the Art Center School. For fifteen years he wrote "Counsel by Connell," a column for *US Camera*. He was also the author of three books, *In Pictures* (1937), *Missions of California* (1941), and *About Photography* (1949). He died in Los Angeles.

### Imogen Cunningham (1883–1976)

Imogen Cunningham was born in Oregon on April 12, 1883, and grew up in Seattle. She decided to become a photographer after seeing Gertrude Käsebier's work. Cunningham attended the University of Washington and continued her studies in photographic chemistry at the Technische Hochschule in Dresden. She later opened a successful photography studio in Seattle. She married an artist, Roi Partridge, and moved to San Francisco just before the end of World War I. Although she was originally a Pictorialist, she became a member of Group f/64 in 1932. In 1967 she was made a Fellow of the American Academy of Arts and Sciences, an honor granted only to one other woman, dancer and choreographer Martha Graham. Cunningham died in San Francisco on June 23, 1976.

### William E. Dassonville (1879–1957)

William Dassonville exhibited in the first three San Francisco Photographic Salons of 1901, 1902, and 1903. He was active in the California Camera Club and a contributor to *Camera Craft*. His experiments with the platinotype-glycerin process produced soft Tonalist landscapes. After the 1906 earthquake Dassonville left San Francisco for the Sierra Nevada. He eventually returned to reestablish his San Francisco studio, but in 1924 sold this business in order to concentrate full time on the manufacture of photographic paper. "Dassonville Paper," with its soft velvety surface, ideal for printing deep blacks, was a favorite among Pictorialist photographers.

### James N. Doolittle (c. 1890–c. 1950)

James N. Doolittle was born around 1890 in Danbury, Connecticut. By 1915, while he was living in the San Francisco Bay Area, his amateur work was being published internationally. He moved to Los Angeles before 1920, where he found employment as a Hollywood studio photographer. He was well known during the 1930s for his color advertising and portrait work. Doolittle

became an early member of the Camera Pictorialists of Los Angeles and was elected director of the club from 1930 to 1932. He died in Los Angeles in the early 1950s.

### John Paul Edwards (1884–1968)

John Paul Edwards was born in Minnesota on June 5, 1884. He was a member of the Pictorialist Photographers of America, the Oakland Camera Club, the California Camera Club, and the San Francisco Photographic Society. He exhibited widely, participating in Pictorialist salons in London, Los Angeles, Pittsburgh, New York, and Toronto. Although his early works were in the Pictorialist style, in 1932 Edwards became a founding member of Group f/64. He died in Oakland on September 25, 1968.

### Louis Fleckenstein (1866–1942)

Louis Fleckenstein was born in Faribault, Minnesota. He began his artistic life as a painter but switched to photography before 1900. He had immediate success as a Pictorialist, winning numerous medals and awards. He was president of the Salon Club of America and helped establish the First American Photographic Salon. Fleckenstein came to Los Angeles in 1907 and was a vital force in the establishment of several camera clubs, including the Camera Pictorialists of Los Angeles, for which he served as director. He maintained a portrait studio in Los Angeles until 1923. He lived in Long Beach for many years thereafter, serving on the city's first arts commission and continuing his Pictorialist work. He died in Long Beach.

### Arnold Genthe (1869–1942)

Arnold Genthe was born in Berlin in 1869. After graduating with a degree in classical philology, he came to San Francisco to tutor the son of a German baron. On his days off Genthe photographed scenes in San Francisco's Chinatown; these photographs were published in local magazines. He was encouraged by the praise they received and decided to open a studio when his engagement as a tutor ended. He soon became one of San Francisco's premiere professional portrait photographers. His entire studio and life's work, except for the Chinatown negatives, were destroyed in the 1906 earthquake and fire. He moved to New York in 1911, where he continued to prosper as a portrait photographer.

### Louis Goetz (active 1914–1930s)

Louis Goetz was a Berkeley photographer who first exhibited his work in 1914 at the California Camera Club. In 1922 he took up bromoil transfer printing and, in a matter of months, became an acknowledged expert. Goetz was active in the California Camera Club for many years, exhibiting in several major national and international salons through the 1930s.

### Fletcher O. Gould

Fletcher O. Gould lived in Pasadena. He began to exhibit his work during the late 1920s, becoming a member of the Camera Pictorialists of Los Angeles in 1934. He was employed in various jobs related to photography, such as taking photographs for the Pasadena Police Department and working for a photography supply store. Gould was one of the first photography students at the Art Center School, where he was a pupil of Will Connell. He was also a student of William Mortensen. However, the exotic techniques typical of Pictorialism do not seem to have interested him, as existing prints by him are relatively sharp in focus and straightforward in printing technique.

### Johan Hagemeyer (1884–1962)

Johan Hagemeyer was born in Amsterdam on June 1, 1884. He emigrated with his brothers to California to work as a horticulturist. He contracted pneumonia on a trip to Washington, D.C. and, while recuperating, saw Alfred Stieglitz's *Camera Work* at the Library of Congress. This inspired him to visit Stieglitz in New York. Following this meeting, Hagemeyer decided to become a professional photographer. He returned to California and, after a short apprenticeship in Berkeley, became Edward Weston's assistant in 1917. He operated a succession of portrait studios in the Bay Area and Carmel, where he eventually settled.

### Adelaide Hanscom (1876–1932)

Adelaide Hanscom was born in Empire City, Oregon, in 1876. She enrolled at the Mark Hopkins Institute of Art as a drawing and painting student in 1892. In 1902 Hanscom bought the San Francisco studio of Laura Adams Armer, where she prospered in partnership with the photographer Blanche Cumming. Her photographically illustrated *Rubáiyát of Omar Khayyám* made her an instant celebrity. Like many other San Francisco photographers, her studio and life's work were destroyed in the 1906 earthquake and fire. She relocated to Seattle, where she opened a new studio, and shortly thereafter married Gerald Leeson, an ex-Mountie. The marriage was not a happy one. After a stormy argument, Leeson enlisted in the Canadian army during World War I and died in his first battle. A widow with two children, and lacking support from her family, she entered an artists' colony in Berkeley. She managed to illustrate a second book, *Sonnets from the Portuguese*, before the onset of mental illness, which she fought for the rest of her life. Hanscom was killed in a hit-and-run accident in Los Angeles in 1932.

### Leopold Hugo (1866–1933)

Leopold Hugo was born in Breslau, Germany, on December 24, 1866. He came to the United States to attend college and in 1907 settled with his wife, Emma Pauline Miller, in La Jolla, California, where they opened a grocery store. By 1911 Hugo was listed as a photographer in the city directory. He specialized in landscape and nature studies and his work from that period consists primarily of postcard images of La Jolla. In 1917 he moved to Santa Cruz, where he opened a studio. He was locally renowned for his images of the eucalyptus and cypress trees on the coastline of Monterey. He returned to La Jolla in 1929, reestablished a studio there, produced landscape photographs, and experimented with a variety of photographic processes. He died on September 7, 1933, while visiting Benton, Texas.

### Henry Hussey (1887–1959)

Henry Hussey was born in Sacramento in 1887 and moved to the Bay Area to attend the University of California at Berkeley. He began to be interested in photography while stationed in Germany after World War I. When he returned to San Francisco after the war, he became a founding member of the Pictorial Photographic Society of San Francisco.

### Shinsaku Izumi (1880–1941)

Shinsaku Izumi was born in Japan. He was a member of the Japanese Camera Pictorialists of California, a club whose members worked exclusively in Los Angeles. He first exhibited with the group beginning in 1934, becoming a member a year later. He died in 1941, before Japanese residents of Los Angeles were evacuated to relocation camps.

### Arthur F. Kales (1882–1936)

Arthur F. Kales was born in Phoenix in 1882. He grew up in Oakland and completed a law degree at the University of California, Berkeley, in 1903. He tried his hand at Pictorial photography while living in the Bay Area, enjoying almost instant success. In 1916 he moved to Los Angeles to become advertising manager for Earle C. Anthony, who had been his classmate at Berkeley, but relocated to San Francisco in 1917. He became a member of the Camera Pictorialists of Los Angeles in 1918. From 1922 through 1936 he wrote about developments in Pictorial photography in western America for *Photograms of the Year*. He was made Fellow of the Royal Photographic Society and was included in the John Wanamaker Salon in 1918 and the London Salon in 1920 and 1931. He was given a fifty-print retrospective by the Smithsonian Institution in Washington, D.C., in 1928. He died in Los Angeles.

### Kirby Kean (born 1908)

Kirby Kean was born in Muskogee, Oklahoma. For thirteen years, from 1929 through 1941, he was James N. Doolittle's assistant. He learned photography from Doolittle and helped him to photograph many Hollywood stars. Kean joined the Camera Pictorialists of Los Angeles in 1935. When Doolittle's studio closed in 1941, Kean found employment with one of the airplane manufacturers and ceased working in photography.

### Florence B. Kemmler (1900–1972)

Florence Kemmler began photographing two years after she moved from Columbus, Ohio, to San Diego in 1920. She was closely associated with Roland Schneider—she signed at least one print "Mrs. Roland E. Schneider"—and they photographed together until his death in 1934. She was a member of the Camera Enthusiasts of San Diego, the area's most active photographic club. She was a prodigious exhibitor: according to the *American Annual of Photography* she exhibited 229 prints in 90 salons between 1930 and 1935. Kemmler's work was also included in national traveling exhibitions organized by the Pictorial Photographers of America. She died in San Diego.

### Hiromu Kira (1898–1991)

Hiromu Kira was born in Hawaii but spent most of his youth in Japan. Kira began to practice amateur photography in Seattle, where, in 1924, he was a founding member of the Seattle Camera Club. He moved to Los Angeles in 1926, where he was associated with members of the Japanese Camera Pictorialists of California although he never joined the club. He worked at a variety of jobs, including sewing machine salesman, shoe salesman, photography store clerk, and as a retoucher for RKO Radio Pictures. The 1932 *American Annual of Photography* reported that Kira exhibited 73 prints in 267 salons between 1928 and 1932. Kira was a Fellow of the Royal Photographic Society. He died in Los Angeles.

### Asahachi Kono (active mid-1920s–mid-1930s)

Asahachi Kono was born in Japan. He was a member of the Japanese Camera Pictorialists of California in Los Angeles. Little is known about him, except that he worked as a retoucher in the photography department at RKO Radio Pictures. He returned to Japan before World War II.

### Dorothea Lange (1895–1965)

Dorothea Lange was born in Hoboken, New Jersey, in 1895. She worked for Arnold Genthe in New York and studied with Clarence White at Columbia University. In 1918, while on a world trip, she was marooned in San Francisco when all her possessions were stolen. She decided to remain there and open a studio, and within a year she had a thriving photographic business. At the start of the Depression she was hired by the California State Emergency Relief Administration to photograph migratory workers. Later she continued to photograph migrant workers for the U.S. Resettlement Administration and its successor organizations. She died on October 11, 1965, in California.

### Alma Lavenson (1897–1989)

Alma Lavenson was born in San Francisco in 1897. Initially she worked in the Pictorialist style, but around 1929 she began to explore urban and industrial subjects with a more modernist eye. By 1932 she had joined Group f/64 and abandoned the Pictorialist style altogether. She died in Piedmont, California, on September 19, 1989.

### Helen MacGregor (1876–1954?)

Helen MacGregor was Francis Bruguière's assistant until he moved to New York in 1918. She exhibited at the Oakland Photographic Salon in 1921 before leaving for London, where she enjoyed a long and successful career in commercial photography as the partner of Maurice Beck.

### Margrethe Mather (1885–1952)

Margrethe Mather was born in Salt Lake City. She came to Los Angeles after the turn of the century and had a portrait studio downtown near Angels Flight. After meeting Edward Weston, perhaps at a 1912 Los Angeles Camera Club gathering, she became his assistant and, later, his studio partner. She also had close associations with the Japanese-American community, where she had business dealings and where she juried exhibitions for the local Japanese camera club. Although the formation of the Camera Pictorialists of Los Angeles was her idea and she became a founding member, she soon left the group. During the early 1920s she continued to submit her work to the club's salons. In 1931 she and William Justema, who frequently served as her model in Los Angeles during the 1920s, had a joint exhibition called *Pattern by Photography* at the M. H. de Young Museum in San Francisco. Shortly after this she stopped working in photography and for most of her later years worked for an antiques dealer in Glendale.

### Oscar Maurer (1871–1965)

Oscar Maurer was born in New York. He studied at the University of California, Berkeley, and opened a studio in San Francisco. He was a member of the Photo-Secession and was the first California photographer to come to national prominence: his photographs of the 1906 earthquake, which destroyed his studio, were widely seen. He joined the Camera Pictorialists of Los Angeles before the First International Photographic Salon of 1918 but dropped out of the club after 1926. He died in Berkeley in 1965.

### Edward P. McMurtry (1883–1969)

Edward P. McMurtry was born in Allegheny, Pennsylvania, and lived most of his life in Pasadena. He was educated at Harvard and was independently wealthy. His interests were photography, travel, and all things mechanical: he held patents for a number of tools and inventions related to photography. McMurtry joined the Camera Pictorialists of Los Angeles in 1929. He submitted his work to salons throughout the world and, according to the *American Annual of Photography*, was the second most exhibited Pictorialist in the world between 1930 and 1935, having shown 929 prints in 179 salons. He died in Carmel.

### Toyo Miyatake (1895–1979)

Toyo Miyatake was born in Kagawa Prefecture, Japan. He came to the United States with his family in 1909 and opened his first portrait studio in the Little Tokyo area of Los Angeles in 1923.

He was a member of the *Shakudo-Sha*, the Japanese group that sponsored exhibitions of Edward Weston's work in Little Tokyo. Miyatake was an avid Pictorialist who exhibited in many local Japanese salons and occasionally in the annual Camera Pictorialists of Los Angeles salons. During World War II he documented in photographs the Japanese relocation experience while he was confined at Manzanar Relocation Center. After the war he reopened his portrait studio, which his family continues to operate. He died in Los Angeles.

### William Mortensen (1897–1965)

William Mortensen was born in Park City, Utah, and studied at the Art Students League in New York. Around 1920 he came to Los Angeles, learned photography from Arthur Kales, and joined the Camera Pictorialists of Los Angeles in 1923. He produced stills for various Hollywood films, including Cecil B. De Mille's *The King of Kings*. Between 1932 and 1955 he operated the Mortensen School of Photography, which trained thousands of photographers in his methods. Mortensen authored nine books on photographic technique and during the 1930s wrote a series of widely read articles for *Camera Craft* magazine, in which he presented many of the precepts of Pictorialism. He died in Laguna Beach.

### Robert Officer

Robert Officer was the first student to work under William Mortensen, who tutored him privately. Officer was briefly a Pictorialist while in Los Angeles during the late 1920s. In the early 1930s he moved to Denver, where he was a partner in the Lainson Studio. He returned to Los Angeles and joined the Camera Pictorialists of Los Angeles in 1938. Officer had a studio near the Art Center School and did work for the Hollywood studios. He was a Fellow of the Royal Photographic Society. He died in San Diego.

### Emily Pitchford (1878–1956)

Emily Pitchford was born in Gold Hill, Nevada, in 1878. She attended the Mark Hopkins Institute of Art, where she met Adelaide Hanscom and Laura Adams. Until 1900 she and Adams shared a commercial studio in Berkeley. She won the bronze medal at the Alaska-Yukon Pacific Exhibition in 1909. In 1911 she married William Leo Hussey, a mining engineer, and they moved to South Africa. She returned to the Bay Area in 1921 and died in Berkeley on January 6, 1956.

### Ernest M. Pratt (1876–1945)

Ernest Pratt was a Pictorialist who first worked in Sacramento. His photographs were published in *Photograms of the Year* during the 'teens. He moved to Los Angeles around 1920 and joined the Camera Pictorialists of Los Angeles, dropping from club membership in 1929. He was a commercial photographer and at one time worked with Viroque Baker, whose name appears with his on some photographs.

### J. T. Sata (1896–1975)

J. T. Sata was born in Kagoshima Prefecture, Japan. He painted watercolors as a boy and wanted to become an artist. He turned to photography after 1919, when he emigrated to the United States. He was a member of the Japanese Camera Pictorialists of California. He worked for a greengrocery in Los Angeles until the firm failed in the Depression. He was then employed by Iwata's Art Store, a photography supply dealership that was frequented by most of the Japanese-American photographers who worked in Los Angeles. Sata and his family spent the war years in confinement at the relocation centers at Jerome, Arkansas and Gila River, Arizona. He died in Pasadena.

### Roland E. Schneider (1884–1934)

Roland Schneider was born in San Diego but went to Zurich where he earned a doctorate in law. His interest in photography began as early as 1909, and he was a leading member of the Camera Enthusiasts of San Diego, which organized a yearly national salon. He worked closely with Florence B. Kemmler and, like her, was a prominent exhibitor. He sometimes signed his prints "Dr. Roland E. Schneider." The *American Annual of Photography* noted in 1935 that Schneider had exhibited 267 prints in 93 salons during the previous five years. He died in San Diego.

### Kaye Shimojima

Kaye Shimojima was born in Japan. He had a portrait studio in Sacramento before coming to Los Angeles around 1920. He was largely responsible for the formation in 1923 of the camera club called the Japanese Camera Pictorialists of California in Los Angeles. He was a teacher of many of the club members and, as a photographer and teacher, was accorded great respect. He returned to Japan before 1930, where he continued to photograph until World War II.

### Karl Struss (1886–1981)

Karl Struss was born in New York and studied photography with Clarence White at Columbia University. Struss became a member of the Photo-Secession in 1912, and eight of his photographs were reproduced in *Camera Work*. He invented the widely used Struss Pictorial Lens, which was prized for its soft-focus effects. In 1916 he joined Clarence White and Edward R. Dickson in forming the Pictorial Photographers of America. Struss moved to Hollywood in 1919, hoping to become a cinematographer, and in 1929 shared the first Academy Award for cinematography. Struss joined the Camera Pictorialists of Los Angeles in 1928, having shown at the club's annual salon since 1922. He died in Los Angeles.

### Dain Tasker (1872–1962)

Dain Tasker was a medical doctor and chief radiologist at the Wilshire Hospital in Los Angeles. Tasker experimented for some years with X-rays to produce photographic images that resembled flowers. He printed them with the assistance of Will Connell.

Tasker exhibited these prints in the early 1930s and frequently gave copies to graduating nurses. He died in Oceanside, California.

### Shigemi Uyeda (1902–1980)

Shigemi Uyeda was born in Hiroshima, Japan, and came to the United States in 1920 at the age of eighteen. He was a farmer all of his life, primarily in Lancaster, California. Although he never joined a camera club, he did associate with other Los Angeles Japanese photographers, particularly those he met at a photography supply house, Iwata's Art Store, in Little Tokyo. Uyeda returned to Japan for a visit in the mid-1920s, where he photographed extensively. He and his family were held at the Poston Relocation Center for the duration of World War II. He died in Westminster, California.

### R. L. Van Oosting

R. L. Van Oosting was a Los Angeles Pictorialist for many years as well as a leading member and officer of the Southern California Camera Club and the Los Angeles Camera Club. In the mid-1930s he was also an officer of the Associated Camera Clubs of America, which had its headquarters in Los Angeles.

### Lynton Vinette (1900–1960?)

Lynton Vinette worked in the stills departments and laboratories of a number of Hollywood studios, including Universal and Twentieth Century-Fox. He began to exhibit prints around 1930 and joined the Camera Pictorialists of Los Angeles in 1933. His wife, Lois, was a well-known photography teacher. He died in Los Angeles.

### Herman V. Wall (born 1905)

Herman Wall was born in Milwaukee. He was a student of Will Connell and Fred Archer at the Art Center School, where he later taught. He was associated with advertising photographer Charles Kerlee and became a respected advertising photographer himself. He was a member of the Camera Pictorialists of Los Angeles from 1938. During World War II he lost a leg photographing the D-Day landings on the beaches of Normandy.

### Edward Weston (1886–1958)

Edward Weston was born in Highland Park, Illinois, on March 24, 1886. He first arrived in Southern California in 1906 for an extended visit with his sister, but he returned to the Midwest to study photography at the Illinois School of Photography. He returned to Southern California in 1908, where he became a founding member of the Camera Pictorialists of Los Angeles and an internationally known Pictorialist. A number of his photographs appeared in Pictorial publications such as *Photograms of the Year*. He renounced Pictorialism, however, before leaving for Mexico in 1923. Later he was a member of the important Group f/64, and he was the first photographer to be awarded a Guggenheim Fellowship (1937–1939). His images of shells, peppers, and sand dunes are among the world's best-known photographs, and his life and work are well documented (see Bibliography). He died in Carmel.

### Otis Williams

Otis Williams was born in Springfield, Missouri. He lived in Los Angeles and exhibited in most of the Camera Pictorialist of Los Angeles salons during the 1920s. He became inactive around the mid-1930s.

### Willard E. Worden (1868–1946)

Willard Worden was born in Philadelphia in 1868. He learned photography while stationed in the Philippines during the Spanish-American War. He arrived in California in 1900 and two years later opened a commercial studio in San Francisco. Worden was the official photographer for the 1915 Panama-Pacific International Exhibition in San Francisco. He died in Palo Alto in 1946.

# BIBLIOGRAPHY

### Books

Alinder, Mary Street, and Andrea Gray Stillman, eds. *Ansel Adams: Letters and Images 1916–1984.* New York: Little, Brown and Company, 1988.

Bruguière, Francis. *San Francisco.* San Francisco: H. S. Crocker Co., 1918.

Bunnell, Peter C., ed. *Edward Weston on Photography.* Salt Lake City: Peregrine Smith Books, 1983.

Corn, Wanda. *The Color of Mood: American Tonalism 1880–1910.* San Francisco: M. H. de Young Memorial Museum and the California Palace of the Legion of Honor, 1972.

Cunningham, Imogen. *Photographs. [By] Imogen Cunningham.* Seattle: University of Washington Press, 1970.

Danly, Susan, and Weston J. Naef. *Edward Weston in Los Angeles.* San Marino, Calif.: The Huntington Library and Art Gallery, 1986.

Emerson, Peter Henry. *Naturalistic Photography: For Students of the Art.* London: Sampson Low, Marston, Searle & Rivington, 1889.

Genthe, Arnold. *Pictures of Old Chinatown.* New York: Moffat, Yard and Company, 1908.

———. *As I Remember.* New York: John Day, 1936.

Gover, C. Jane. *The Positive Image: Women Photographers in Turn-of-the-Century America.* Albany: The State University of New York Press, 1988.

Harker, Margaret. *Henry Peach Robinson, Master of Photographic Art, 1830–1901.* Oxford: Basil Blackwell, 1988.

Heyman, Therese Thau. *Anne Brigman, Pictorial Photographer/Pagan/Member of the Photo-Secession.* Oakland: The Oakland Museum, 1974.

Khayyám, Omar, with an English translation by Edward Fitzgerald. *The Rubáiyát of Omar Khayyám.* New York: Dodge Publishing Co., 1905.

Lange, Dorothea. *Photographs of a Lifetime.* New York: Aperture, 1982.

Maddow, Ben. *Edward Weston: Fifty Years.* Millerton, N.Y.: Aperture, 1973.

Mann, Margery. *Imogen Cunningham: Photographs.* Seattle: University of Washington Press, 1970.

Moholy-Nagy, Laszlo. *The New Vision: Fundamentals of Design, Painting, Sculpture, Architecture.* New York: W.W. Norton & Co., 1938.

Mortensen, William. *Monsters and Madonnas: A Book of Methods.* San Francisco: Camera Craft, 1936.

Naef, Weston J. *The Collection of Alfred Stieglitz: Fifty Pioneers of Modern Photography.* New York: Metropolitan Museum of Art, 1978.

Newhall, Beaumont. *The History of Photography: From 1839 to the Present.* New York: Museum of Modern Art, 1982.

Newhall, Nancy, ed. *The Daybooks of Edward Weston, Volume I. Mexico.* Rochester: George Eastman House, 1961. Copyright 1981, Center for Creative Photography, University of Arizona, Arizona Board of Regents.

———. *The Daybooks of Edward Weston, Volume II. California.* Rochester: George Eastman House, 1961. Copyright 1981, Center for Creative Photography, University of Arizona, Arizona Board of Regents.

Palmquist, Peter E. *Shadowcatchers: A Directory of Women in California Photography.* Vol. 2, 1900–1920. Arcata, Calif.: privately published, 1991.

Robinson, Henry Peach. *Pictorial Effect in Photography.* London 1869. Reprint, Pawlet, Vt.: Helios, 1971.

———. *The Elements of a Pictorial Photograph.* Bradford, England: Percy Lund & Co., Ltd., 1896.

### Catalogues

Fels, Thomas Weston, et al. *Watkins to Weston: 101 Years of California Photography, 1849–1950.* Santa Barbara: Santa Barbara Museum of Art with Roberts Rinehart Publishers, 1992.

Fuller, Patricia Gleason. *Alma Lavenson.* Riverside, Calif.: California Museum of Photography, 1979.

Mann, Margery. *California Pictorialism.* San Francisco: San Francisco Museum of Modern Art, 1977.

Novakov, Anna. *John Paul Edwards.* Oakland: The Oakland Museum, 1987.

Reed, Dennis. *Japanese Photography in America, 1920–1940.* Los Angeles: Japanese American Cultural and Community Center, 1985.

Shipounoff, Dimitri, and Gail Marie Indvik. *Adelaide Hanscom Leeson: Pictorialist Photographer 1876–1932.* Carbondale: Southern Illinois University Press, 1981.

### Unpublished Manuscripts

Connell, Will. Holograph manuscript, Will Connell Collection, Department of Special Collections, University Research Library, UCLA.

Miottel, Katrina. " 'Rebellion in Photography': Northern California Photographers at the Turn of the Century," Stanford University, June 1985.

Tearnen, Janet. "The Photography of Will Connell: Reflections of Southern California, 1928–1950," unpublished field report, University of California, Riverside, 1992.

Unpublished manuscript in a private collection, repr. in Stephen White, *Louis Fleckenstein,* exhibition catalogue (Stephen White's Gallery, 1977).

### Periodicals

Adams, Ansel. "An Exposition of My Photographic Technique." *Camera Craft* (San Francisco) 41 (January 1934).

Adams, Laura M. "The Picture Possibilities of Photography." *Overland Monthly* (San Francisco) 36, no. 213 (September 1900).

Archer, Fred. "The Camera Pictorialists of Los Angeles." *The Pictorialist* (Los Angeles) (1932).

Bland, W. R. "Observations on Some Pictures of the Year." *Photograms of the Year,* 1916 (London) (1917).

Blumann, Sigismund. "Our Japanese Brother Artists." *Camera Craft* (San Francisco) 32 (March 1925).

———. "Arthur F. Kales, F.R.P.S." *Photo-Era* (Boston) 2 (November 1934).

———. "Arthur F. Kales, A Militant Pictorialist Who Really Pictorializes." *Camera Craft* (San Francisco) 37 (December 1930).

Breck, Henrietta S. "California Women and Artistic Photography." *Overland Monthly* (San Francisco) 43 (February 1904).

Brigman, Anne. "Awareness." *Design for Arts in Education* 38 (June 1936).

Brigman, Annie. "Starr King Fraternity Exhibition." *Camera Craft* (San Francisco) 10 (April 1905).

Caffin, Charles. "The Development of Photography in the United States." *Art in Photography*, London: The Studio (1905).

"Club Notes." *Camera Craft* (San Francisco) 10 (April 1905).

Crowninshield, Frank. Foreword. *Pictorial Photography in America* (New York) 5 (1929).

Dassonville, William E. "Individuality in Photography." *Overland Monthly* (San Francisco) 40, no. 4 (October 1902).

Davie, Helen L. "Women in Photography." *Camera Craft* (San Francisco) 5 (August 1902).

Demachy, Robert. "On the Straight Print." *Camera Work* (New York), no. 19 (1907).

Doubleday, J. Walter. "Photography in Commercial Designing." *Camera Craft* (San Francisco) 26 (July 1918).

Dyer, William B. "The Chicago Salon." *Camera Notes* (New York) 4 (July 1900).

Editorial. *Camera Craft* (San Francisco) 1 (August 1900).

Editorial. *Camera Craft* (San Francisco) 4 (January 1902).

Editorial. *Camera Craft* (San Francisco) 5 (June 1902).

Editorial. *Camera Craft* (San Francisco) 6 (February 1903).

Erwin, James W. "A Pacific League of Camera Clubs." *Camera Craft* (San Francisco) 1 (May 1900).

"A Few Words of Criticism Upon the Work of Each Exhibitor, Leveled in a Kindly Spirit by the Editor, with Reproductions of Striking Pictures." *Camera Craft* (San Francisco) 5 (June 1902).

Fleckenstein, Louis. "Why I Am a Pictorial Photographer." *Photo-Era* (Boston) 62 (January 1929).

"Louis Fleckenstein." Editorial. *Photo-Era* (Boston) 24 (January 1910).

Fraprie, Frank Roy. "The First American Photographic Salon in New York." *Photo-Era* (Boston) 13 (December 1904).

———. "Our Illustrations." *The American Annual of Photography 1928* (New York) 42 (1927).

Frith, Francis. "The Art of Photography." *The Art Journal* (London) 5 (1859).

Genthe, Arnold. "The Children of Chinatown." *Camera Craft* (San Francisco) 2 (December 1900).

———. "The Rebellion in Photography." *Overland Monthly* (San Francisco) 43 (August 1901).

———. "What Various Prominent Critics Have to Say of the Second San Francisco Photographic Salon Just Passed." *Camera Craft* (San Francisco) 4 (February 1902).

———. "The Third San Francisco Salon." *Camera Craft* (San Francisco) 7 (November 1903).

Hamilton, Emily J. "Some Symbolic Nature Studies From the Camera of Annie W. Brigman." *Craftsman* (Eastwood, New York) 12 (September 1907).

Haz, Nicholas. "Picture Analysis." *American Photography* (New York) 31 (October 1937).

Irmas, Deborah. "A Mortensen Sampler." *Camera Arts* (New York) 2 (January/February 1982).

James, George Wharton. "Books and Writers." *Sunset Magazine* (San Francisco) 16 (March 1906).

Kales, Arthur F. "The Second International Salon at Los Angeles." *Photo-Era* (Boston) 62 (February 1919).

Keller, Ulrich F. "The Myth of Art Photography: A Sociological Analysis." *History of Photography* (London) 8, no. 4 (October–December 1984).

———. "The Myth of Art Photography: An Iconographic Analysis." *History of Photography*. (London) 9, no. 1 (January–March 1985).

Kira, Hiromu. "Still Life Photography." *Camera Craft* (San Francisco) 35 (August 1928).

Lamb, Louis B. "The Second Chicago Photographic Salon." *Camera Craft* (San Francisco) 3 (October 1901).

Maloney, Tom, ed. "Will Connell." *U.S. Camera International Annual 1963* (New York) (1962).

Maurer, Oscar. "A Plea for Recognition." *Camera Craft* (San Francisco) 1 (June 1900).

Mortensen, William. "Venus and Vulcan: An Essay on Creative Pictorialism: Interpretations of Reality." *Camera Craft* (San Francisco) 41 (March 1934).

"Pictorialists vs. New York Salon." Editorial. *Photo-Era* (Boston) 13 (October 1904).

"The Photo Secession." *Camera Work* (New York) 3 (July 1903).

"Pope Stieglitz." Editorial. *Photo-Era* (Boston) 12 (July 1904).

Robinson, Henry Peach. "Do Something Better." *Pacific Coast Photographer* (San Francisco) 1 (1892).

"The Southern California Camera Club." Editorial. *Photo-Era* (Boston) 37 (September 1916).

Stellman, L. J. "California Camera Club." *Photo-Era* (Boston) 29 (October 1912).

Stern, Jenny. "Unleashing the Spirit: The Photography of Anne Brigman." *Art of California* (Saint Helena, Calif.) 5 (September 1992).

Stieglitz, Alfred. "The Photo-Secession—Its Objects." *Camera Craft* (San Francisco) 7 (August 1903).

Tilney, F. C. "Pictorial Photography in 1921." *Photograms of the Year, 1921* (London) (1922).

———. "American Work at the London Exhibitions." *American Photography* (New York) 21 (December 1927).

Treat, Archibald. "Important Lessons of the First Salon." *Camera Craft* (San Francisco) 2 (February 1901).

"Works of Nature and Works of Art." *Vanity Fair* (New York) 6, no. 4 (June 1916).

### Newspaper Articles, Interviews, and Other

Armitage, Merle. "The Spirit of the Machine," in unidentified newspaper (20 June 1930), Will Connell Collection, UCLA.

Connell, Will. Introduction. *The 31st International Salon of Photography*. The Camera Pictorialists of Los Angeles, 1950.

"Fear Retards Woman, Avers Mrs. Brigman." *San Francisco Call* (8 June 1913).

Halsman, Philippe. Tribute in *U.S. Camera International Annual 1963* (New York, 1962): 110.

*In Pictures: A Hollywood Satire*, advertising brochure, c. 1937, Will Connell Collection, UCLA.

Miyatake, Toyo. *A Life in Photography: The Recollections of Toyo Miyatake*. Claremont, California: Oral History Program, Claremont Graduate School, 1978.

*Soviet Foto*, no. 12, 1927.

Zeitlin, Jake. *Books and the Imagination: Fifty Years of Rare Books*, oral history 1980, Department of Special Collections, University Research Library, UCLA.

# LENDERS

**To The J. Paul Getty Museum**

Susan Ehrens
Emeryville

James Marrin
Pasadena

Merrily and Tony Page
Page Imageworks
San Francisco

Paul Sack
San Francisco

San Francisco Museum of Modern Art

Marjorie and Leonard Vernon
Los Angeles

The Jane and Michael G. Wilson Collection
Topanga

**To The Henry E. Huntington Library and Art Gallery**

Gorden L. Bennett
Kentfield

The J. Paul Getty Museum
Malibu

Audrey and Sydney M. Irmas
Los Angeles

Tom Jacobson
San Diego

Earle A. Kales
Studio City

The Los Angeles County Museum of Art

The Miyatake Family
San Gabriel

Dennis and Amy Reed
Thousand Oaks

Craig Struss Rhea
Los Angeles

Frank T. Sata
Pasadena

Togo Tanaka
Los Angeles

The Uyeda Family
Palos Verdes Estates

Stephen White Collection (II)
Los Angeles

Marjorie and Leonard Vernon
Los Angeles

The Jane and Michael G. Wilson Collection
Topanga

# INDEX TO PHOTOGRAPHERS AND WORKS